All About
DRAWING

Wild Animals & Exotic Creatures

Step-by-step illustrations by Robbin Cuddy & Diana Fisher

Table of Contents

Getting Started

When you **look** closely at the **drawings** in this book, you'll notice that they're made up of basic shapes, such as circles, triangles, and rectangles. To draw all your favorite animal friends, just start with simple shapes as you see here. It's easy and fun!

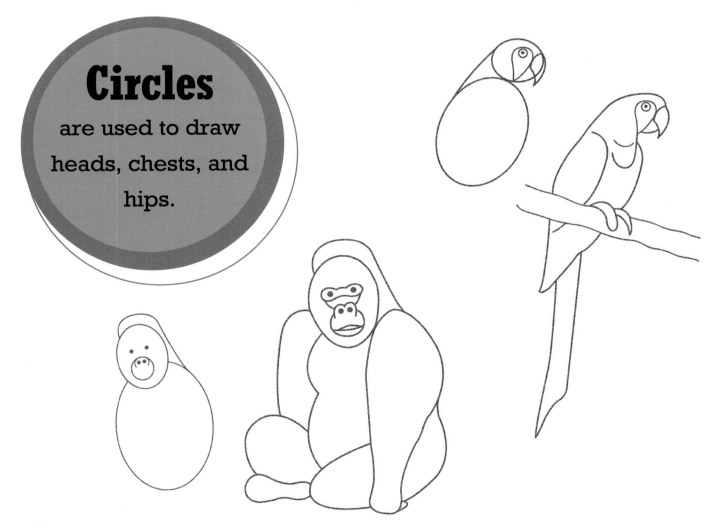

Circles are used to draw heads, chests, and hips.

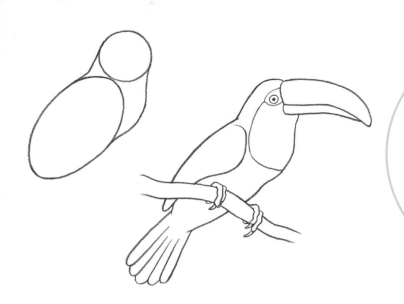

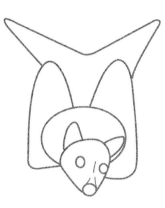

Ovals

make good profile heads and beaks.

Triangles

are best for angled parts, like wings and ears.

FIND THE SHAPE!

Can you find circles, ovals, and triangles on the Luna Moth? Look closely. It's easy to see the basic shapes in any creature once you know what to look for!

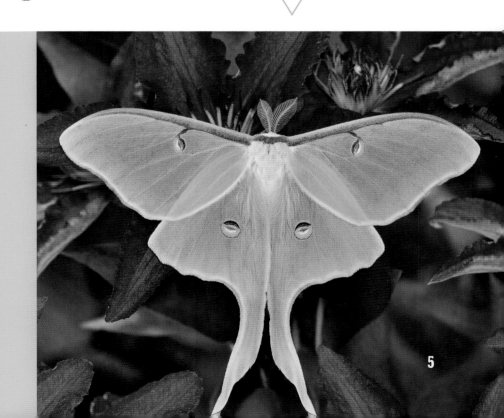

Drawing Exercises

Warm up your hand by drawing lots of squiggles and shapes.

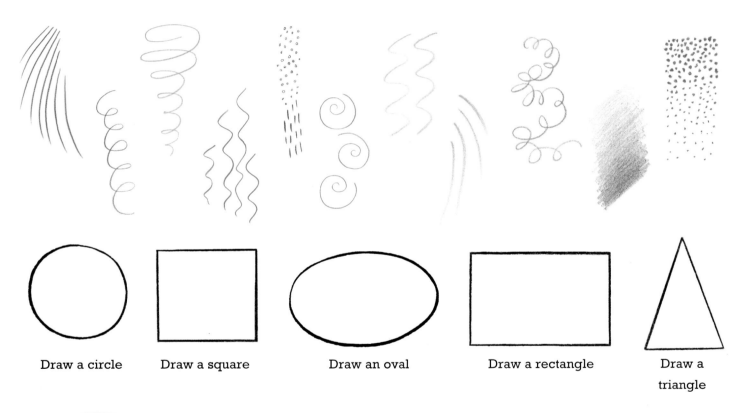

Draw a circle Draw a square Draw an oval Draw a rectangle Draw a triangle

FUN TIP!

With an assortment of animals to portray, the color possibilities are endless! Before you pick a coloring tool for your drawing, think about the animal's different textures. Is its skin furry, feathered, scaled, or smooth? Colored pencils have a sharp tip that is great for tiny details like small hairs and feathers. Crayons can be used to cover large areas quickly, and markers make your colors appear more solid. Try watercolor for a soft touch.

Tools & Materials

Gather some drawing tools, such as paper, a pencil, an eraser, and a pencil sharpener. When you're finished drawing you can add color with crayons, colored pencils, markers, or even paint.

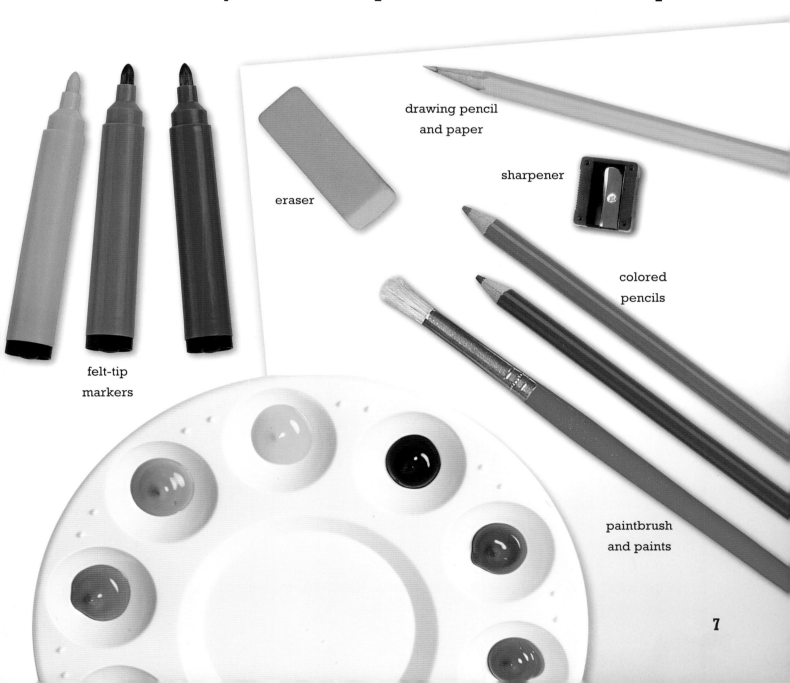

drawing pencil and paper

sharpener

eraser

colored pencils

felt-tip markers

paintbrush and paints

Toucan

This popular bird is known for its super-sized, rainbow-colored bill. The **curved bill** is great for getting food in hard-to-reach places!

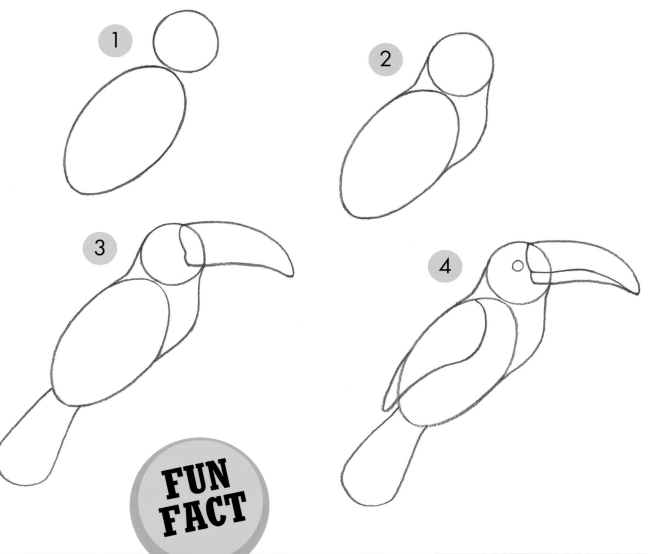

FUN FACT

The toucan's closest relative is the woodpecker. The two birds look very different, but they actually have a lot in common. Both move around on strong feet with two toes pointed backward and two pointed forward. They also have long, skinny, feather-like tongues.

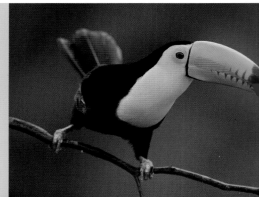

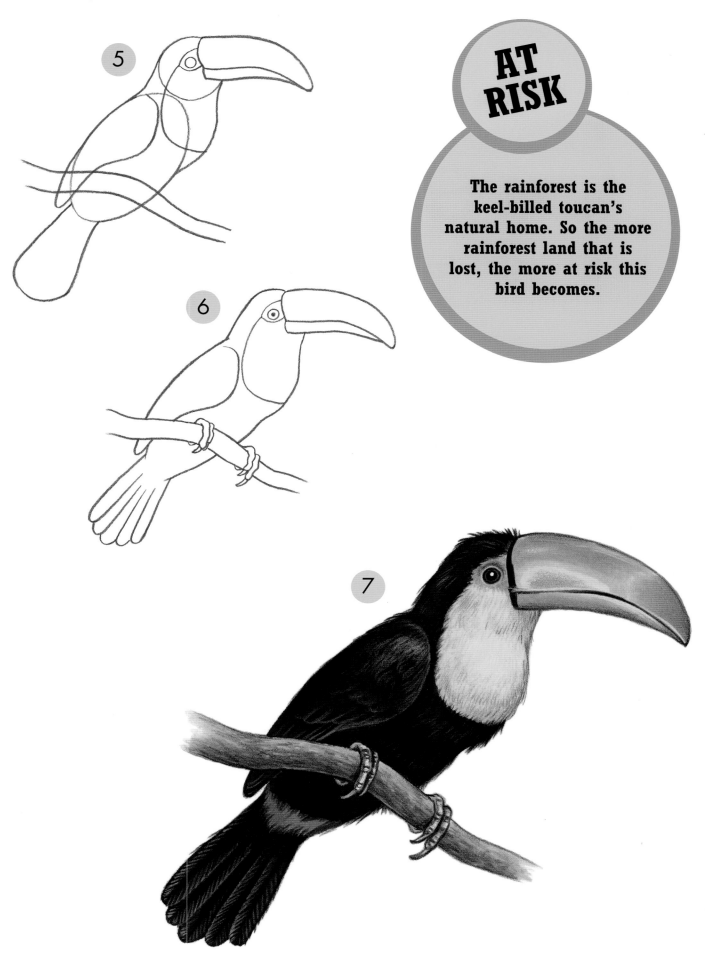

5

6

7

9

Sonoran Green Toad

A vivid **green** color and **black** net-like pattern distinguishes this desert-dwelling hopper, which is among the smallest of the toad species.

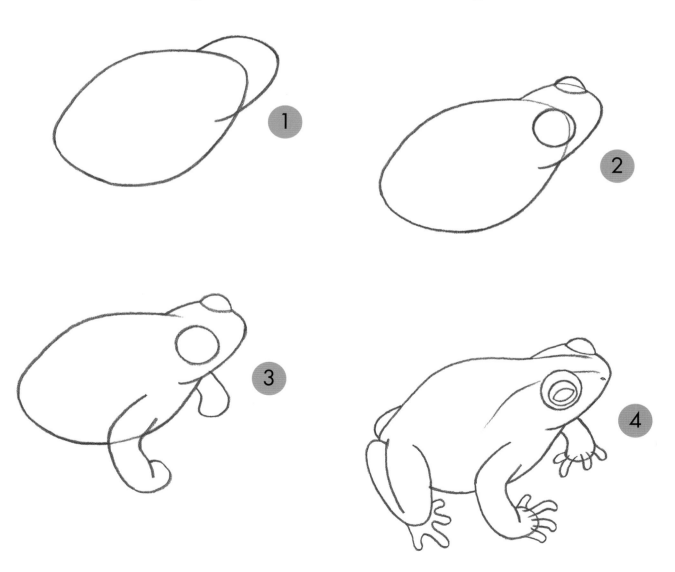

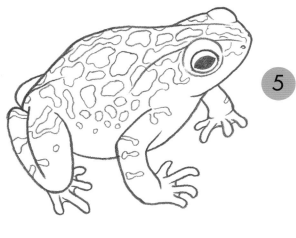

5

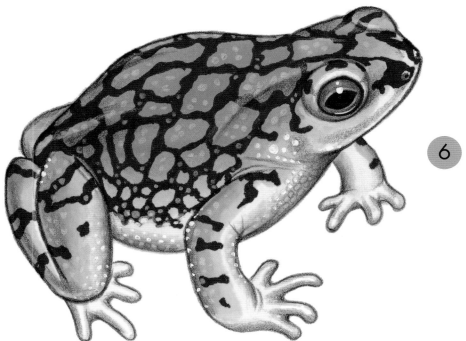

6

FUN FACT

Have you ever heard the call of a toad? Some sound like a noisy sheep, while others sound like they're snoring! This toad makes a high-pitched call that sounds like a combination of a buzz and a whistle, and can be heard at quite a distance—but only at night, since these toads are nocturnal.

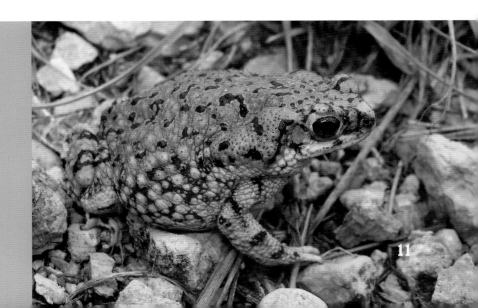

Tokay Gecko

The largest Asian gecko has a **heavy** body and **big**, **striking** eyes. Its distinctive blue-gray skin is enhanced by its polka-dot markings.

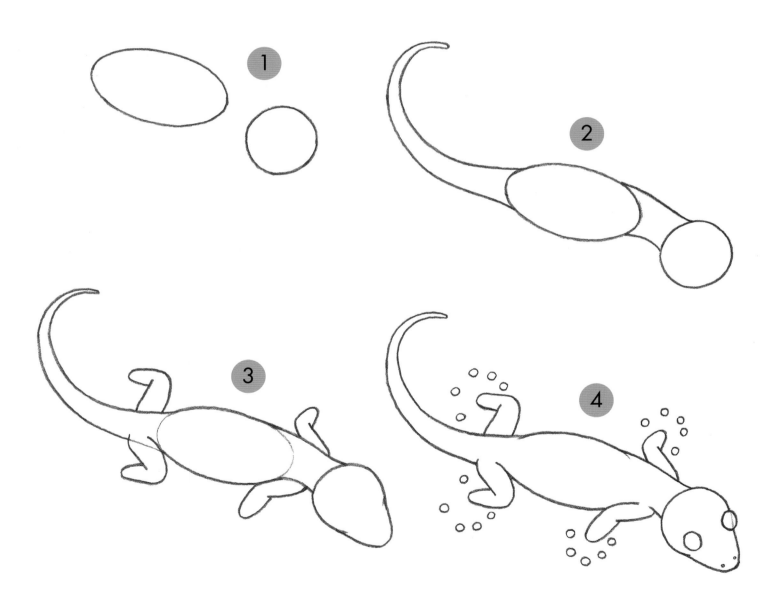

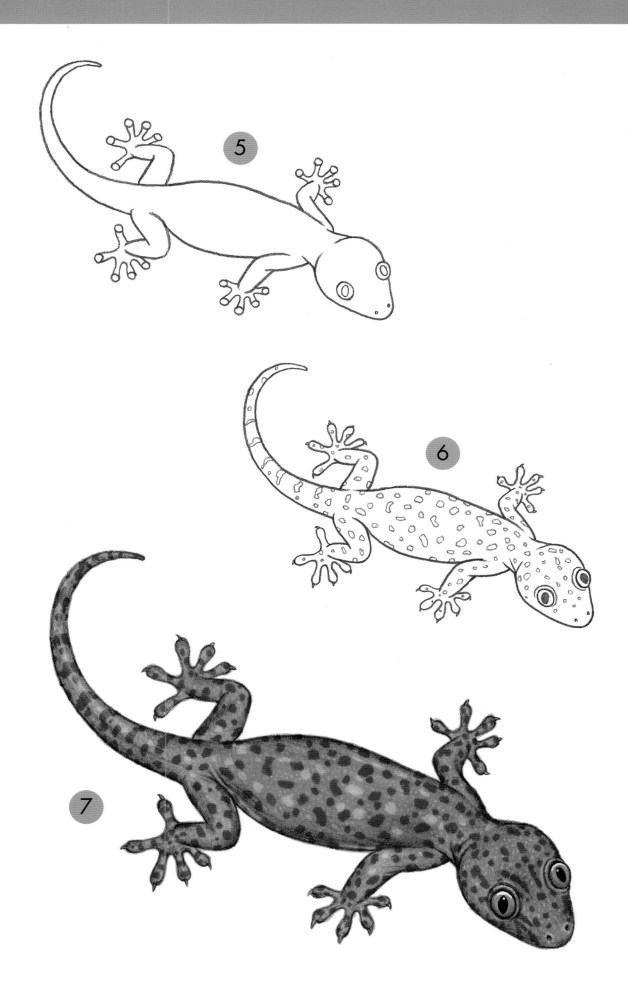

Stink Bug

Bold colors warn would-be predators that this shield bug tastes foul—if the bug's signature smell doesn't scare them off first!

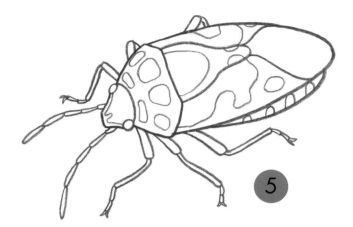

5

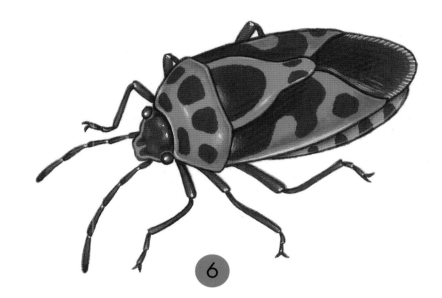

6

Many bugs travel to warmer places in the winter because their bodies can't take the cold—but glycerol in the stink bug's bloodstream acts as an antifreeze, keeping its body from freezing in winter.

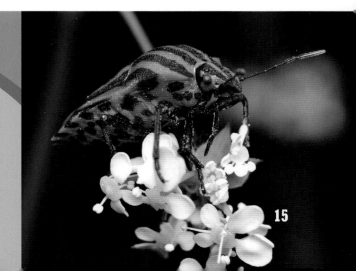

American Alligator

An alligator's **powerful tail** accounts for half
of its length—and it's the tail that makes
the alligator such a good swimmer!

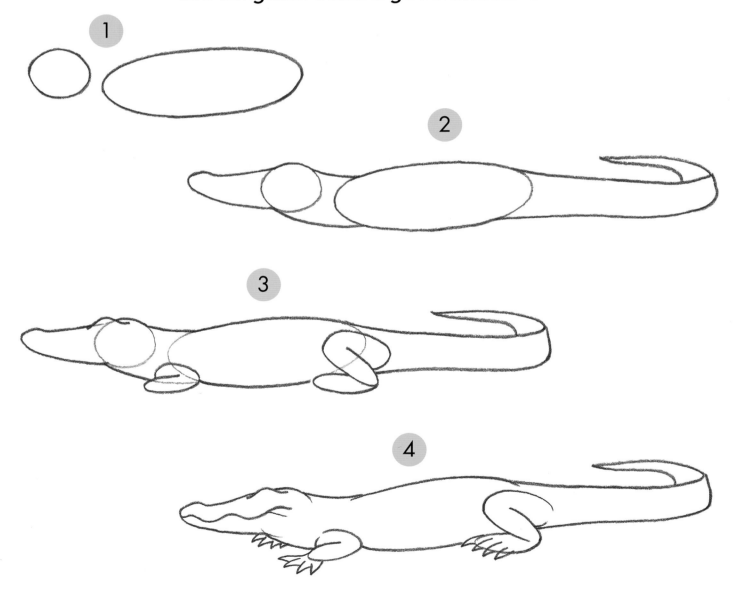

5

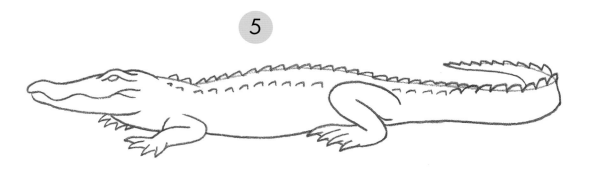

6

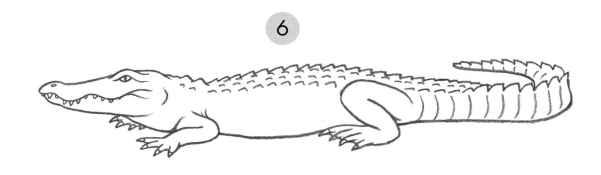

7

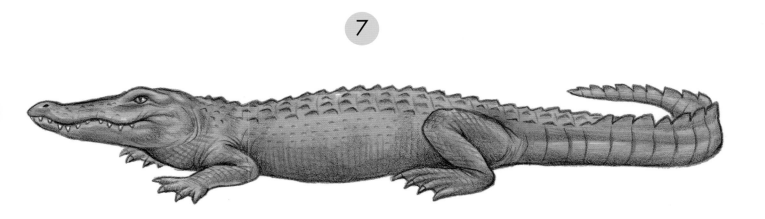

Gorilla

This **gentle giant** has a cone-shaped head, and its arms are longer than its legs. Gorillas love to eat and nap all day!

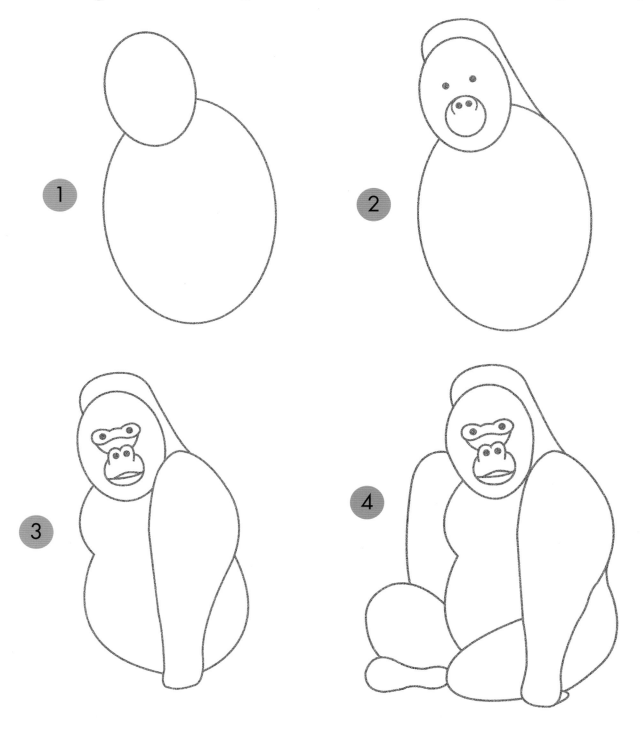

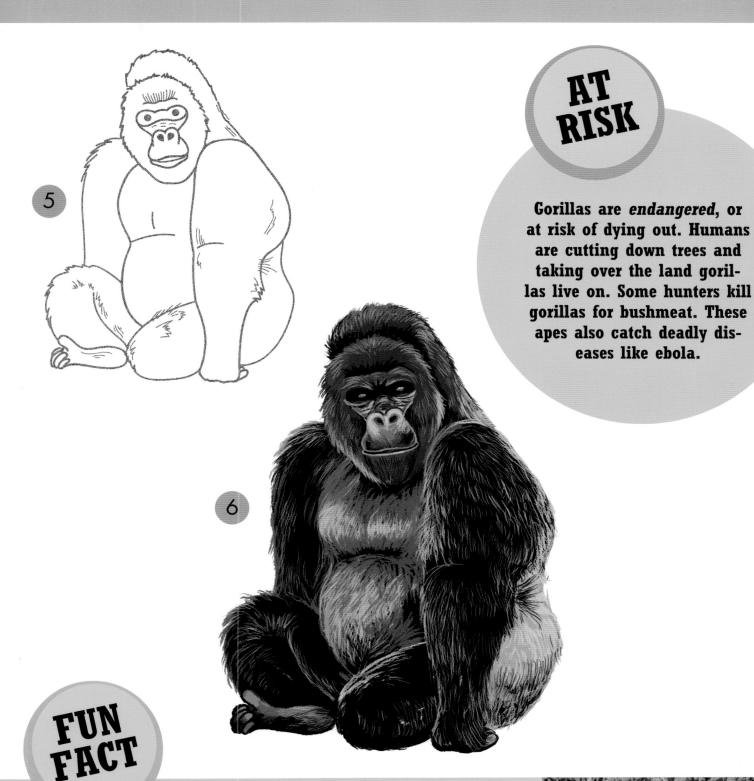

5

6

Gorillas are *endangered*, or at risk of dying out. Humans are cutting down trees and taking over the land gorillas live on. Some hunters kill gorillas for bushmeat. These apes also catch deadly diseases like ebola.

FUN FACT

Gorillas are the largest *primates*, a group of animals that includes other apes and humans. Like humans, each gorilla has a different set of fingerprints. Gorillas can also stand on two legs, but they like to knuckle walk on their curled fingers and feet. Gorillas are very smart, and some have been taught to use sign language!

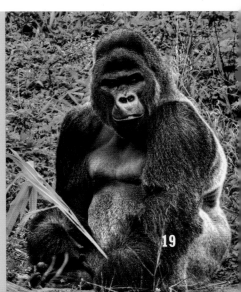

Jaguar

Jaguars are large **wild** cats. Most have tan or orange-brown fur with black spots called **"rosettes."**

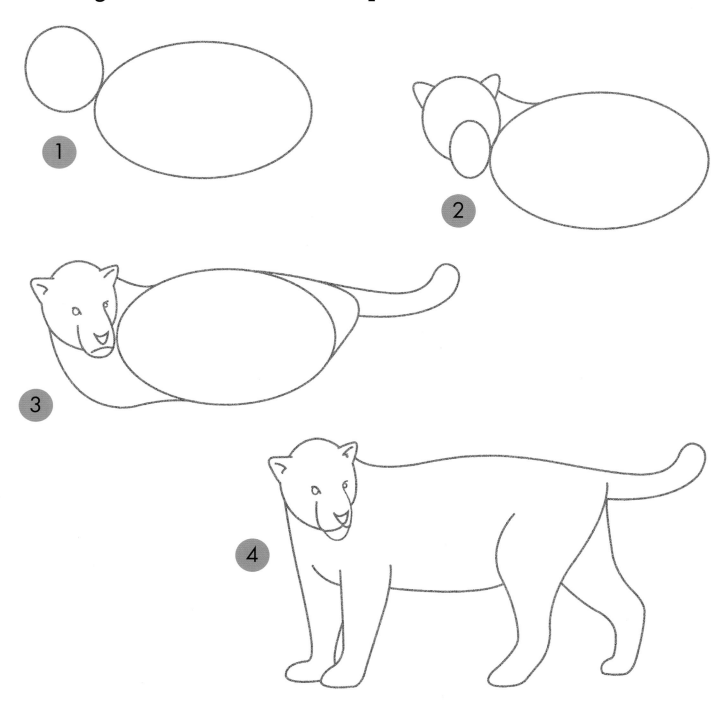

5

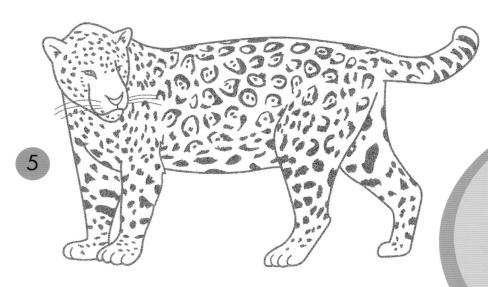

Jaguar *habitats*, or natural environments, are being destroyed by humans. With shrinking hunting grounds, some jaguars eat animals on ranches. Ranchers often catch and poison them. Some humans also hunt jaguars for their beautiful fur.

6

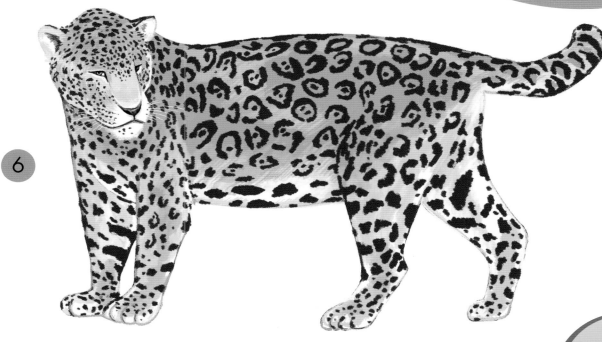

FUN FACT

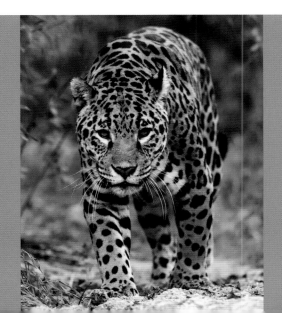

Your housecat may hate the water, but jaguars are excellent swimmers! They love to play in rivers and streams. Jaguars mostly look for *prey*—or animals they can eat—on the ground, but they also hunt in the water. Sometimes a jaguar may climb a tree to pounce on animals below.

Flying Fox

This **furry** flier is not a fox. It's a large **fruit** bat!
It has big, round eyes and wide wings.

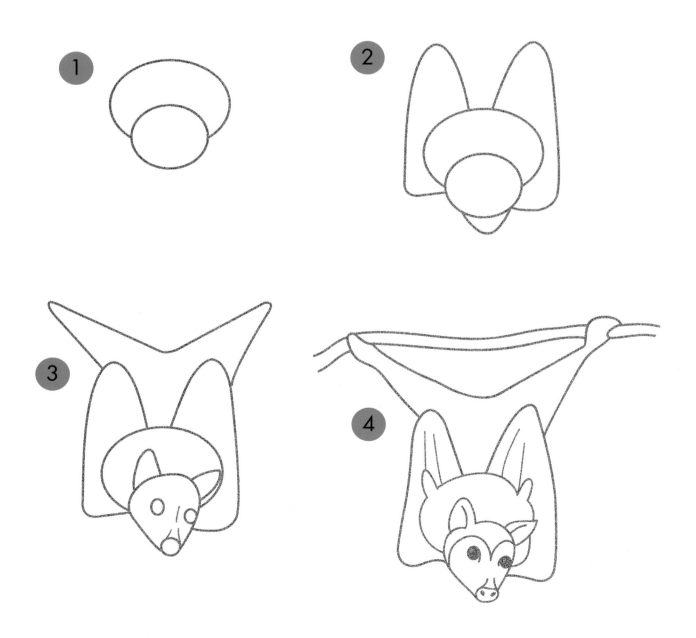

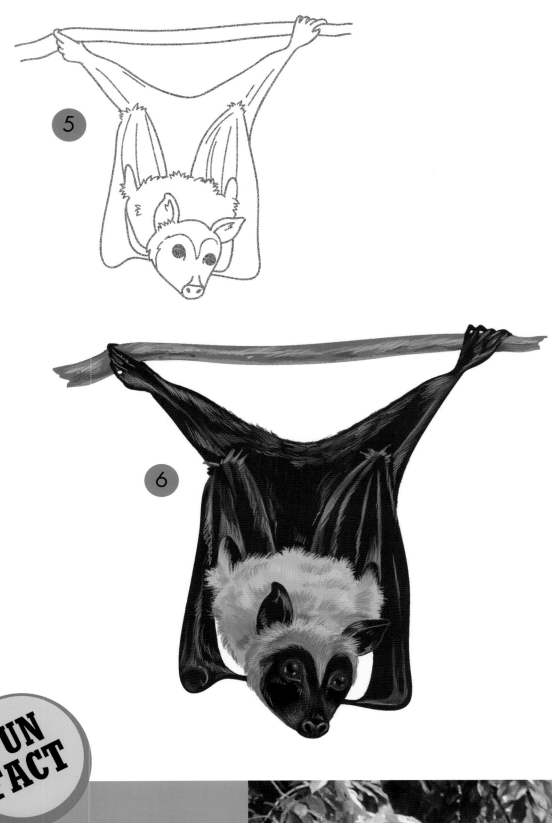

5

6

FUN FACT

All bats belong to the order *chiroptera*, which means "hand" and "wing" in Greek. Their wings are actually long arms and fingers covered by a thin skin.

Luna Moth

All "moon" moths possess large, **furry** bodies with **broad**, long-tailed wings. But only the male moth sports feathered antennae!

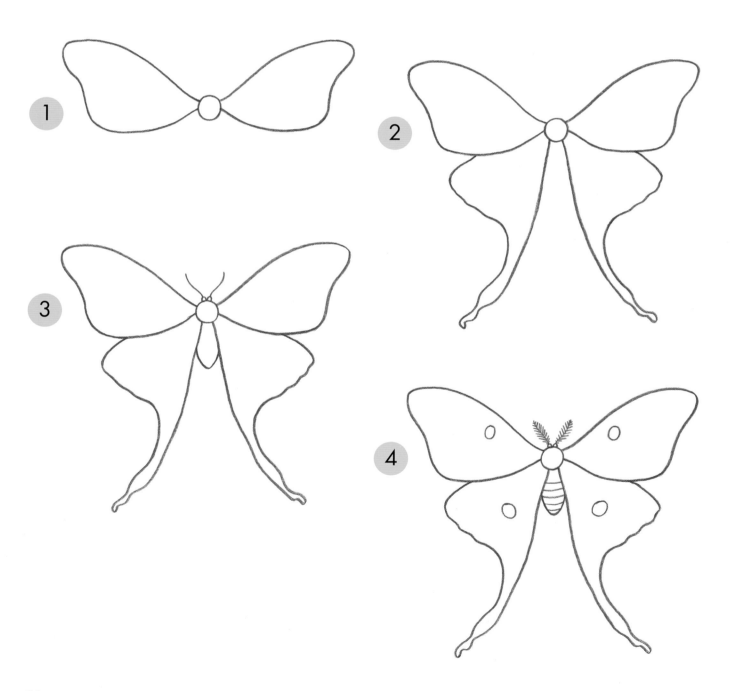

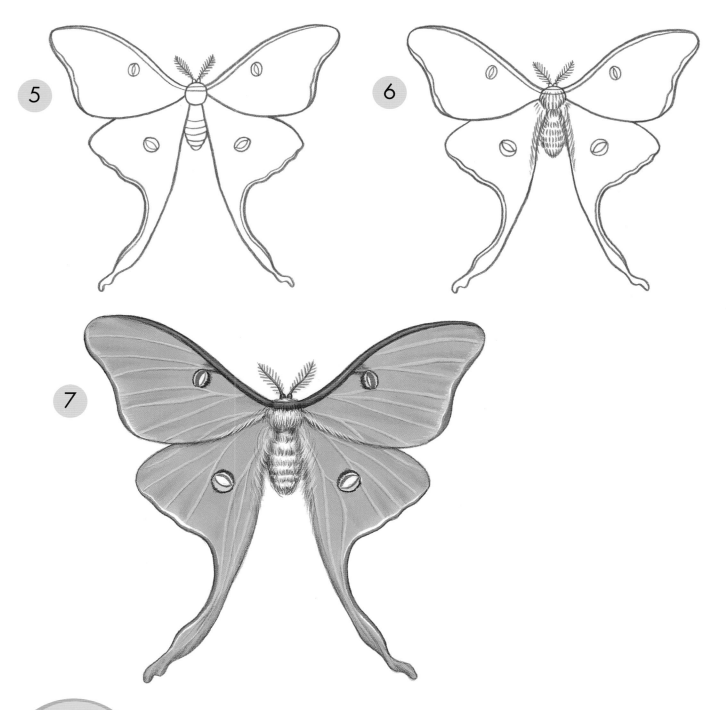

5

6

7

This American moth species is named after the eyespots on its wings, which look like moons. It is also referred to as "luna," "lunar," and "moon" moth—all three names meaning exactly the same thing.

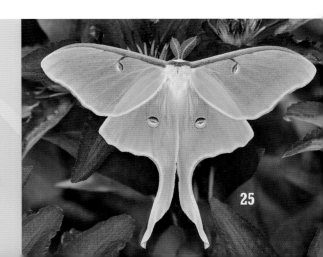

Praying Mantis

Natural coloring and **leafy** wings camouflage the mantis, while large eyes, sharp leg spines, and powerful **jaws** capture its prey.

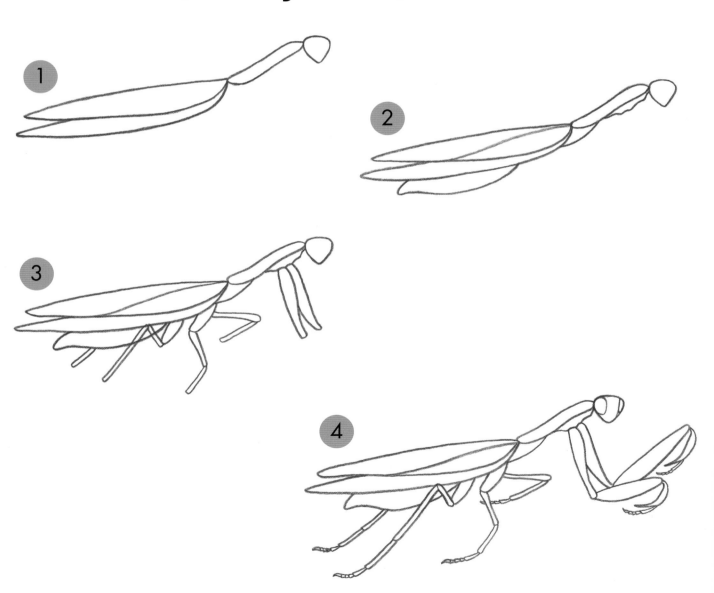

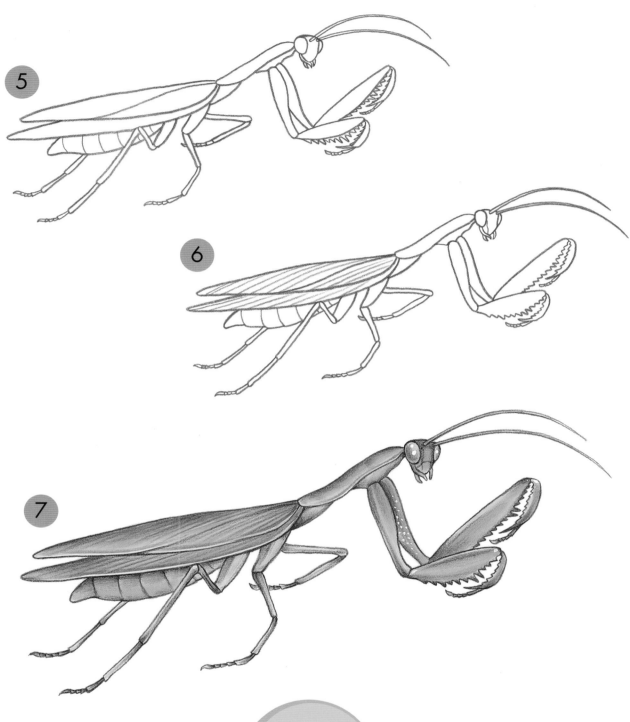

5

6

7

FUN FACT

Legend has it that the female praying mantis always eats the male mantis after mating. While females do sometimes eat their mates—especially if in captivity—most males are not eaten by their partners.

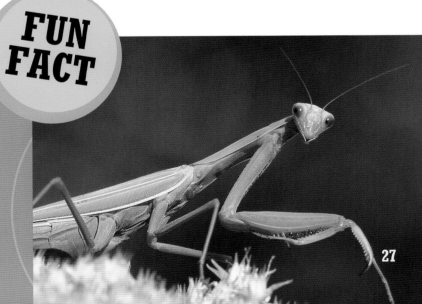

Red-Eyed Tree Frog

With its large **red** eyes, bright green skin, and **sticky** toe pads, it's hard to confuse this rainforest-dwelling hopper with any other!

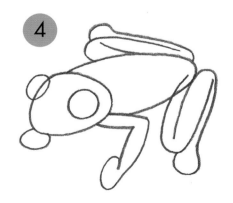

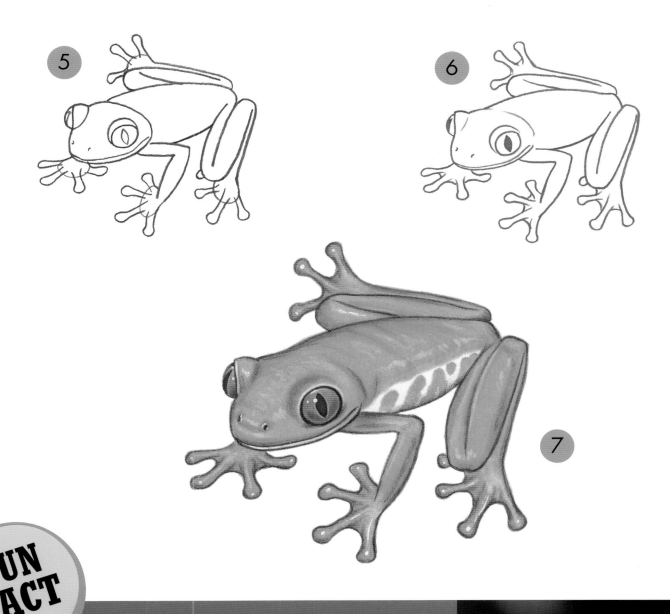

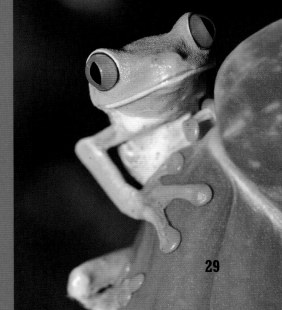

This frog can change its vivid green color to a shade that camouflages in its environment, but it "flashes" its other colors for protection. Suddenly opening its red eyes or displaying the blue stripes on its midsection can startle or confuse a predator, giving the frog time to hide or escape!

Lorikeet

Lorikeets are one of the most **colorful** types of parrots.
They have long, pointed **tails** and a brush-like tongue.

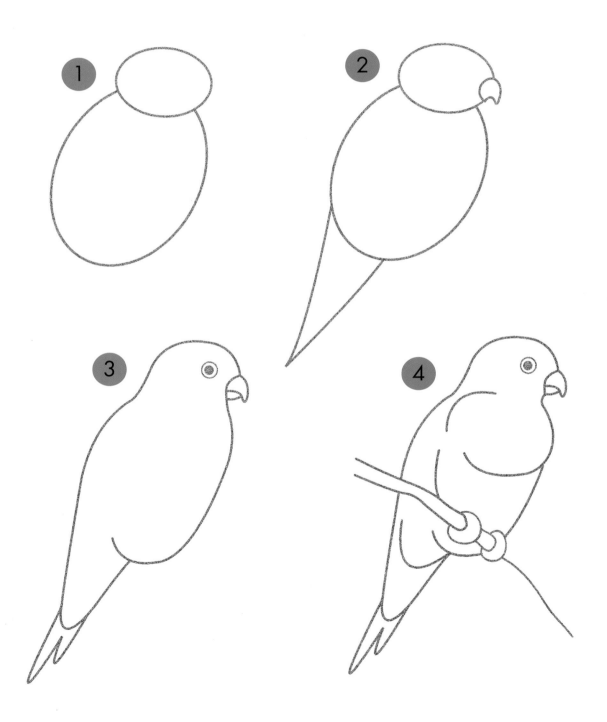

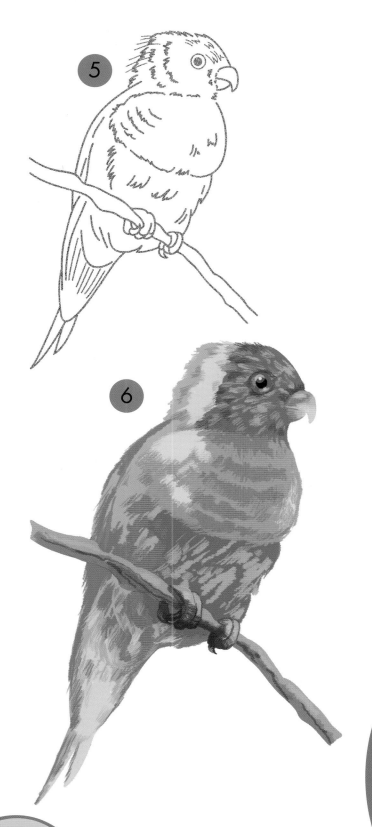

5

6

AT RISK

Humans pose a big threat to lorikeets. These birds are killed for their beautiful feathers or caught and sold as pets.

FUN FACT

Lorikeets love to eat! They are also called "honeyeaters" because they snack on flowers, pollen, and nectar all day. To feed on hard-to-reach flowers, a lorikeet can hang upside down!

Sun Bear

The sun bear got its name from the curved mark on its chest that looks like the **rising sun**.

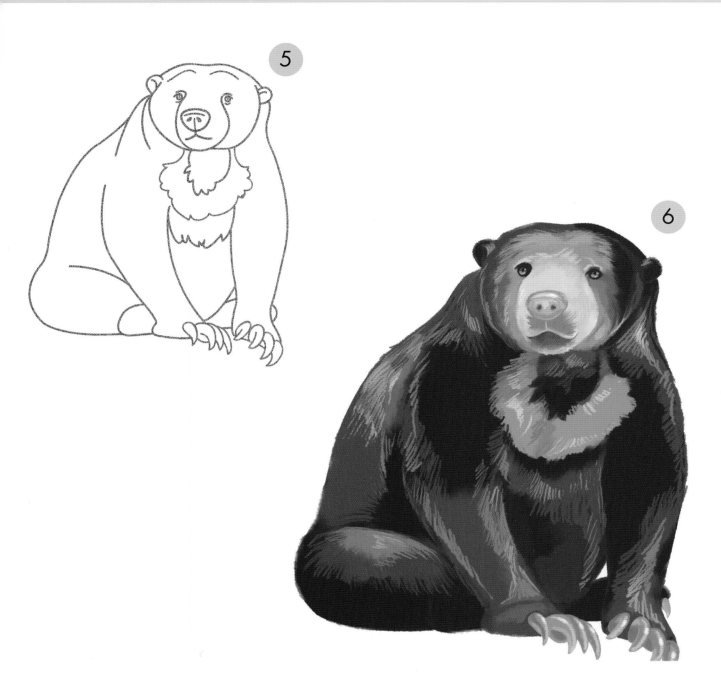

5

6

FUN FACT

The sun bear is the smallest bear in the world. It is also called the "dog bear" for its small size, light-colored muzzle, and muscular build. Sun bears have long tongues perfect for getting honey out of beehives, earning them their other nickname, "honey bears."

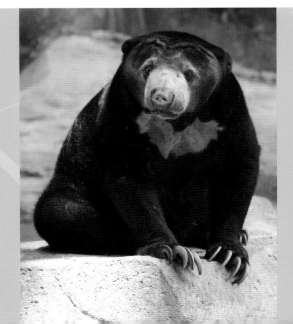

33

Green Iguana

The iguana's versatile **tail** acts as a **whip** in fights and a propeller when swimming. It can also be shed if the lizard is in danger!

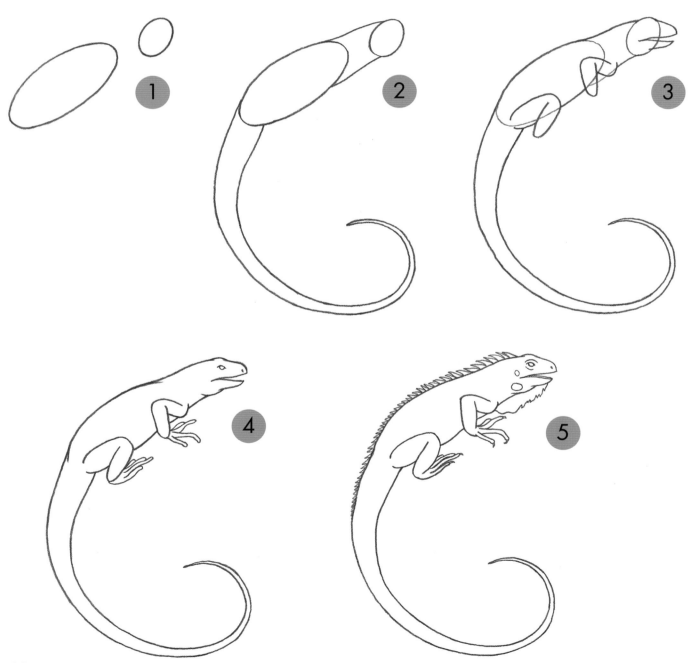

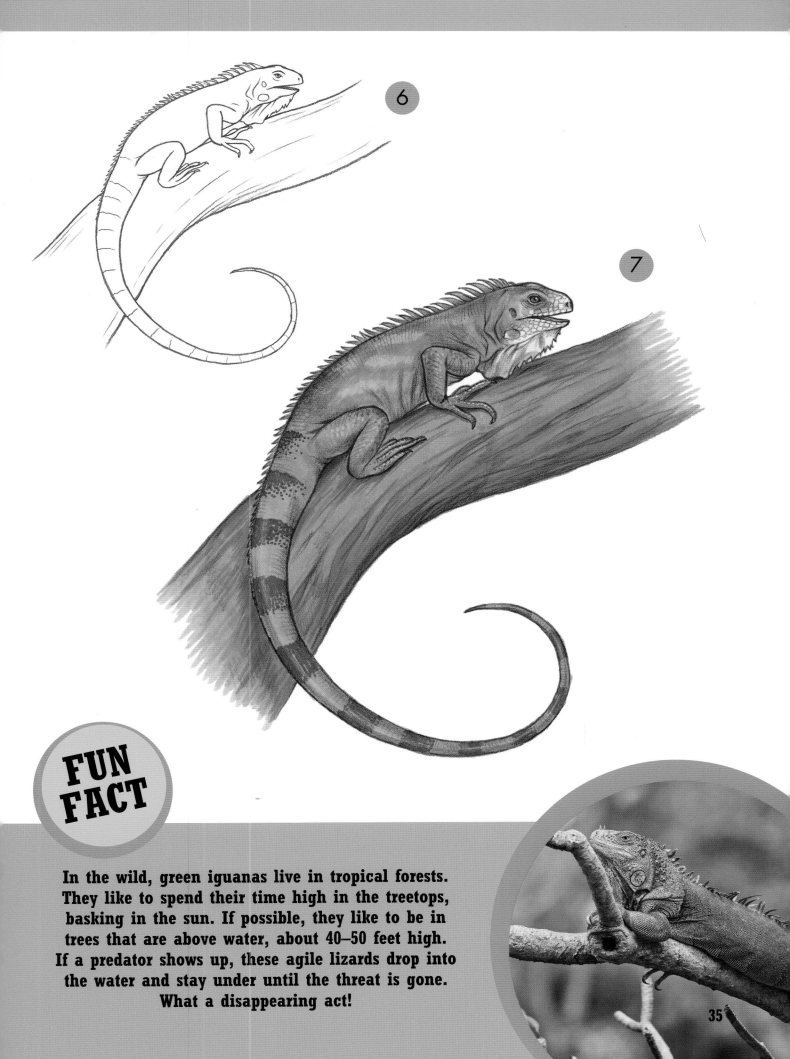

6

7

FUN FACT

In the wild, green iguanas live in tropical forests. They like to spend their time high in the treetops, basking in the sun. If possible, they like to be in trees that are above water, about 40–50 feet high. If a predator shows up, these agile lizards drop into the water and stay under until the threat is gone. What a disappearing act!

35

Jackson's Three-Horned Chameleon

The male of this species has a **prehistoric** look—its three "horns" make it look like a distant relative of the triceratops!

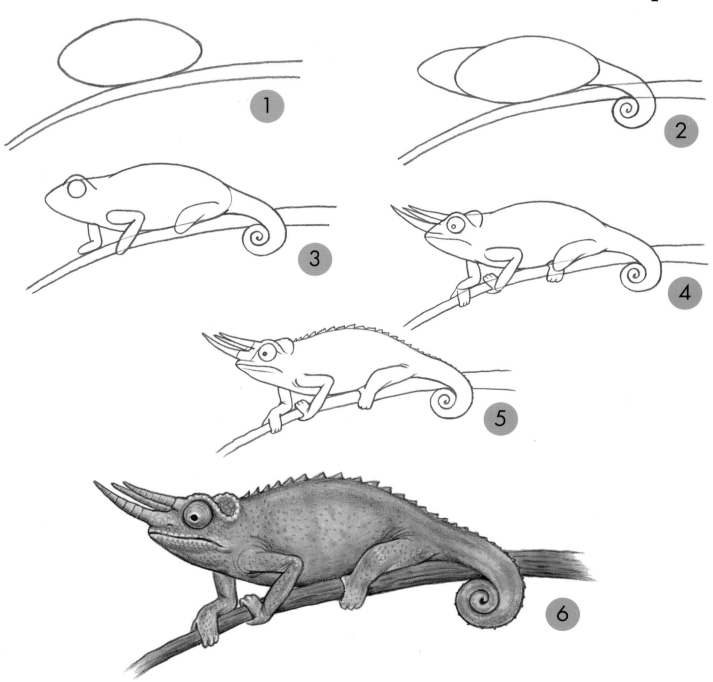

Eastern Snake-Necked Turtle

This Australian turtle has a **unique** talent—it can stand at the bottom of a river and use its long neck to **peek** out at the surface.

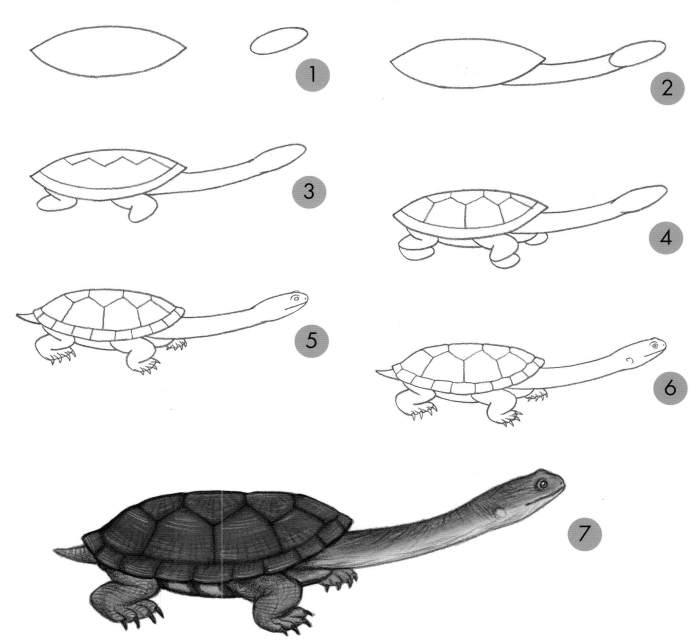

Broad-Winged Damselfly

Features like its **round** eyes and **slender** body are dragonfly-like, but the damsel's folded wing pairs are all its own!

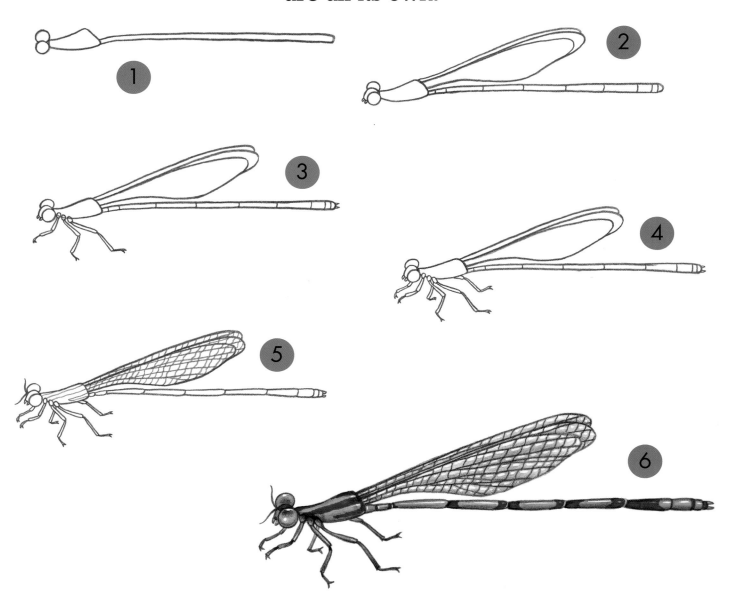

Fulgorid Bug

For a master of camouflage, this **odd** bug with a unique head shape sure stands out! It **startles** predators with its bright wings.

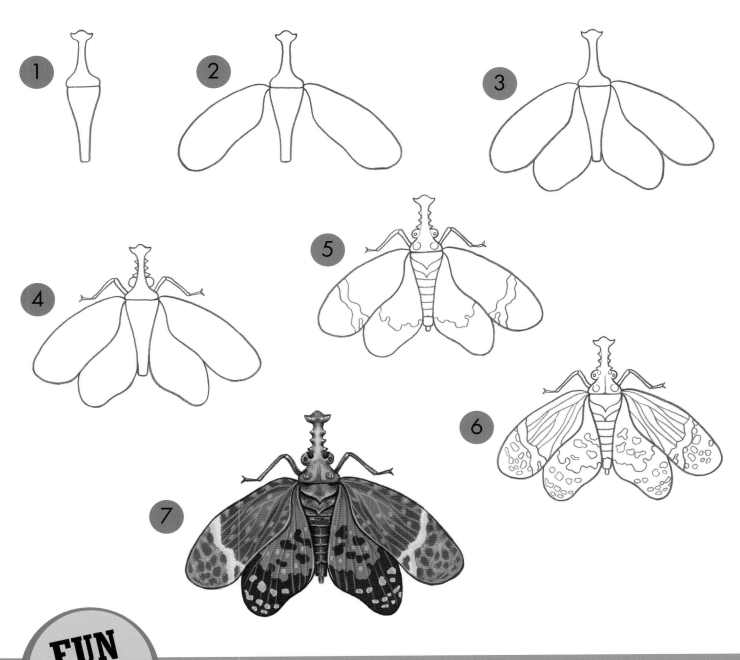

This planthopper is found on vegetation in Panama, Brazil, and Columbia, feeding on plant sap. Its dew-like body waste acts as food for its protector, the ant!

Yellow Jacket Wasp

All social wasps have tiny waists and warning coloration, such as the **bright** yellow **patches** that cover this species' black body.

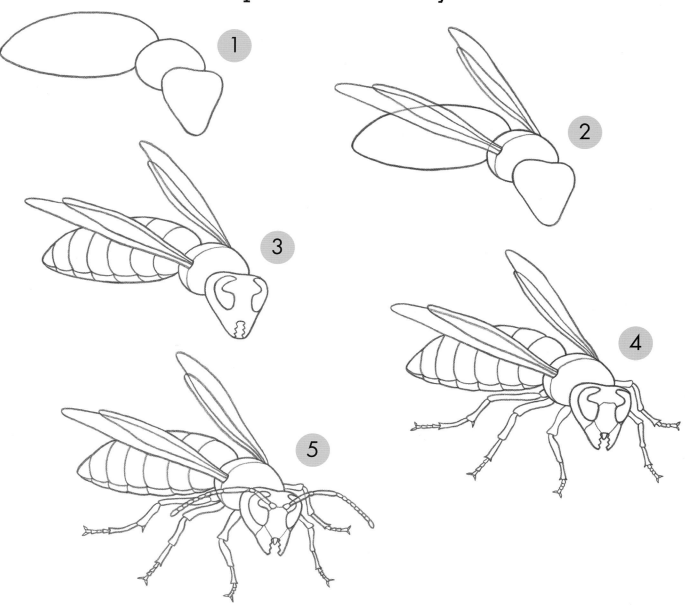

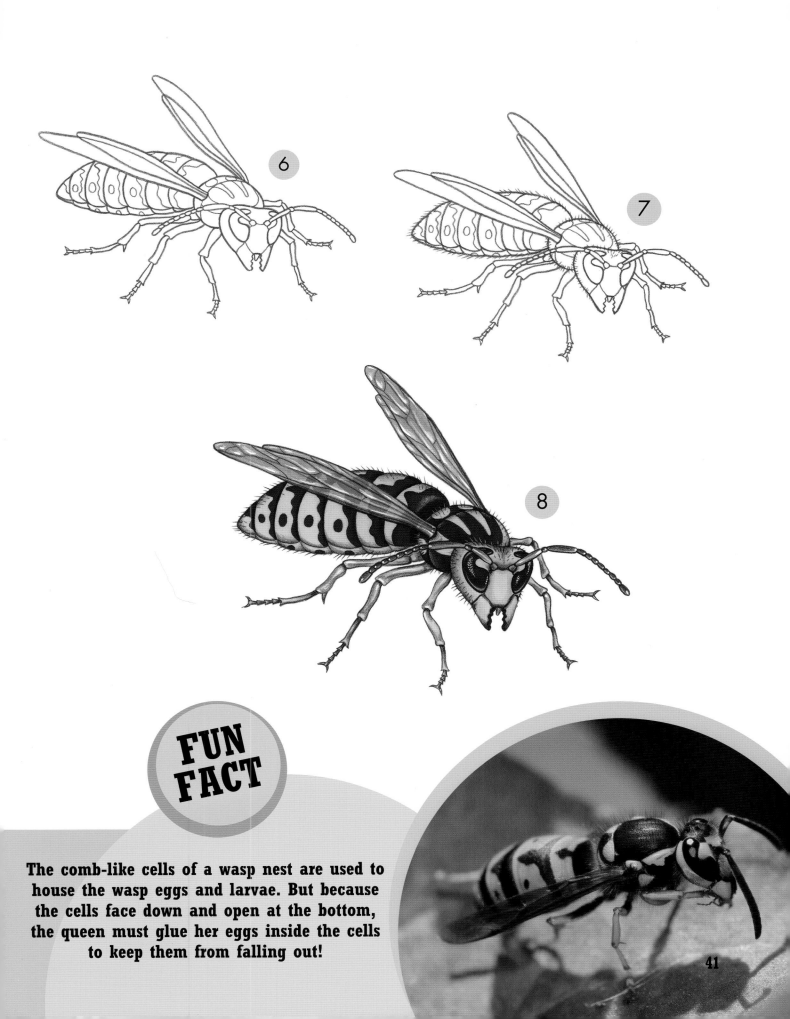

6

7

8

The comb-like cells of a wasp nest are used to house the wasp eggs and larvae. But because the cells face down and open at the bottom, the queen must glue her eggs inside the cells to keep them from falling out!

Australian Frilled Lizard

This **small** reptile has a fancy **frill** that folds in neat pleats on its neck when it's calm, but it puts on quite a show when threatened!

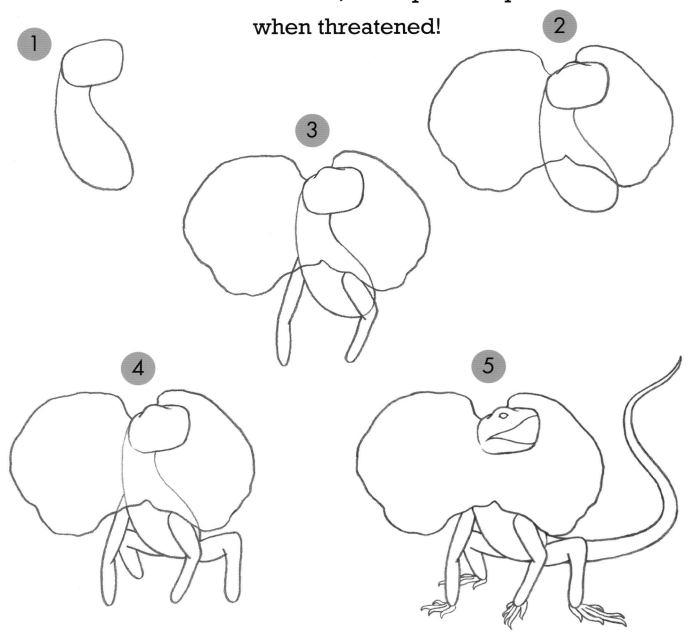

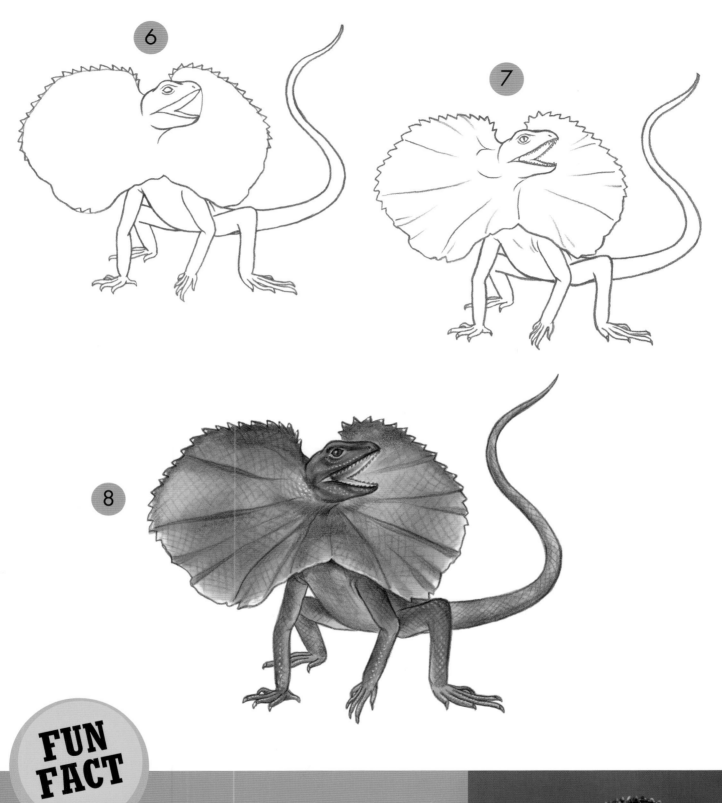

6

7

8

This lizard stands up to predators—as a last resort! First it will lay low to the ground, camouflaging its body. If the threat remains, it will raise its frill, open its colorful mouth, and whip its tail in a menacing fashion. Finally it will raise its body on its hind legs, hiss, and jump at the predator!

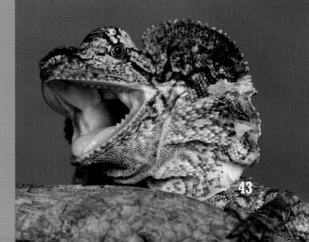

American Green Anole

The dewlap of a male anole is usually bright **pink**. When courting a female anole, the **male** will "flash" his bright colors to get her attention!

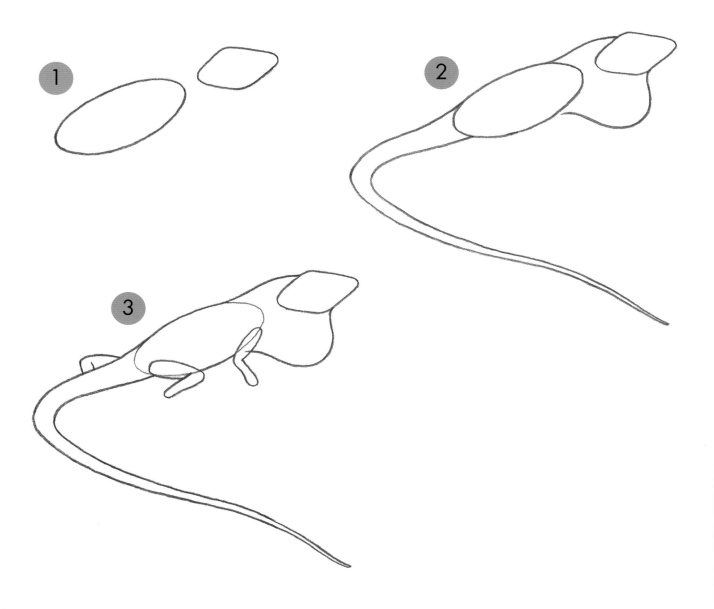

44

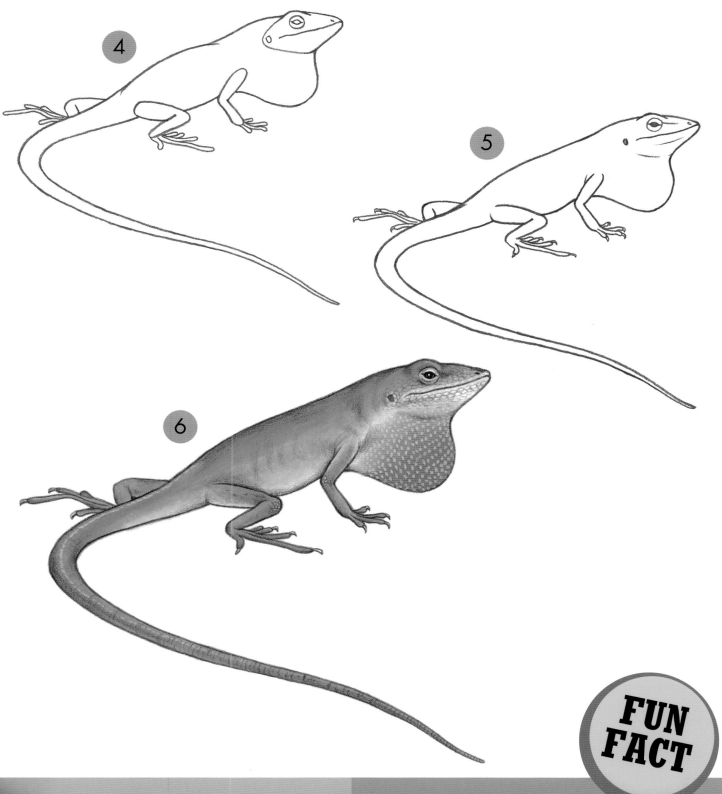

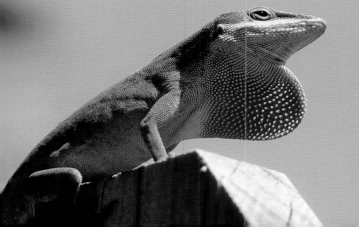

The color of the green anole changes depending on its mood, temperature, and health. Even though they are unrelated to chameleons, they are often referred to as the "American chameleon."

Scarlet Macaw

The scarlet macaw's **bold** red, blue, green, and yellow **feathers** help it blend in with the colorful fruits and flowers of the rainforest.

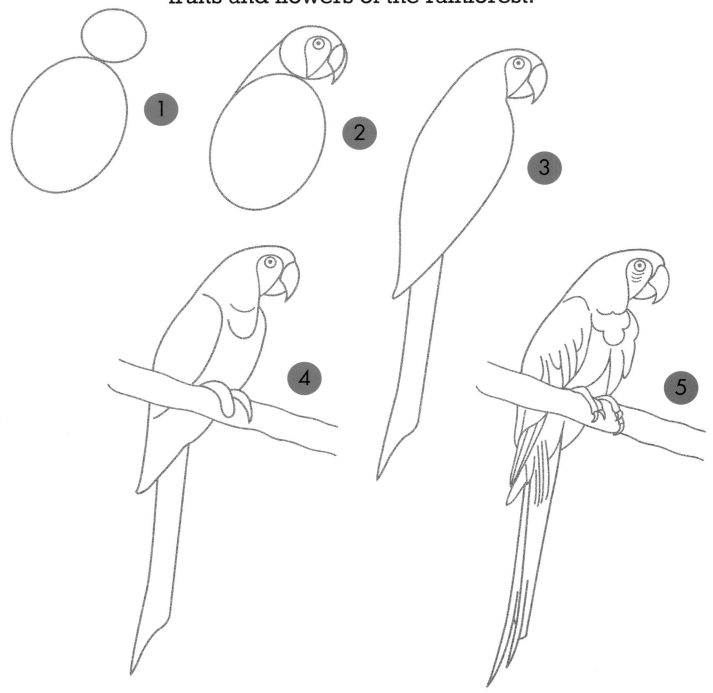

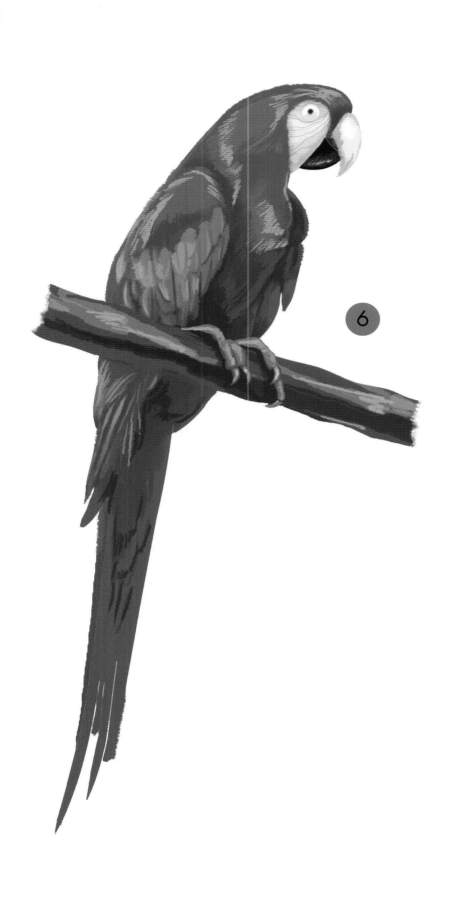

6

Scarlet macaws are left-handed—or footed. They use their left foot to hold things, while balancing on their right foot.

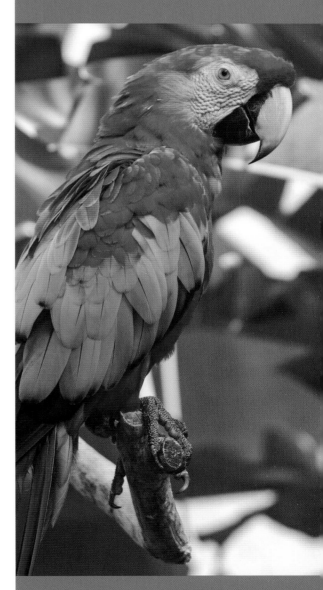

Amazon River Dolphin

The Amazon river dolphin is **pink** with a **long**, thin snout and small eyes.

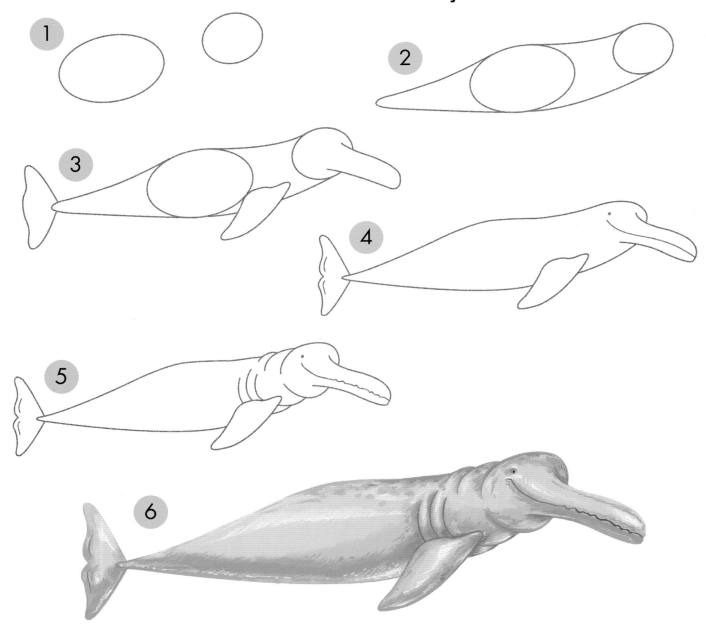

Sloth

A sloth spends most of its time upside down.
Its long, **curved** claws allow it to **hang** from trees.

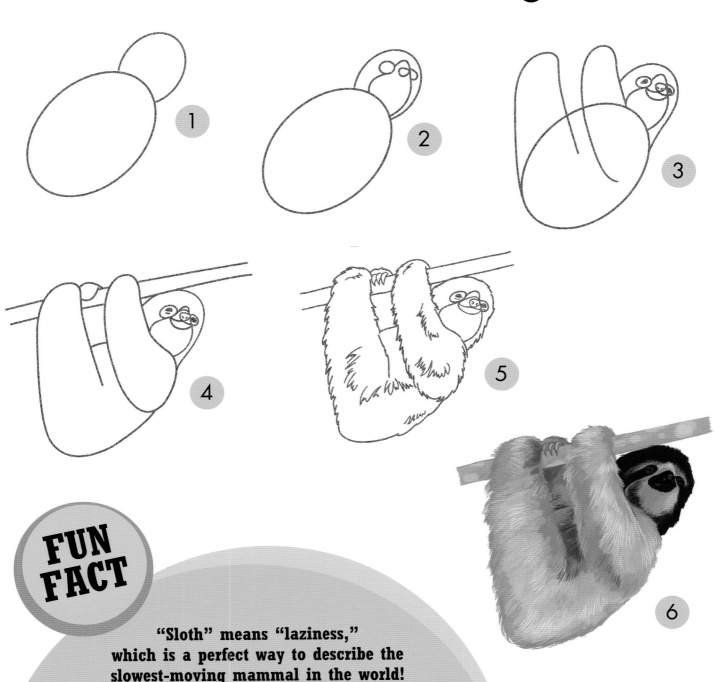

FUN FACT

"Sloth" means "laziness,"
which is a perfect way to describe the
slowest-moving mammal in the world!
Sloths sleep up to 20 hours a day. They stay still
for so long that algae grows on their fur!

Marbled Newt

All newts have thin bodies, **long** tails, and **short** legs. But only the marbled newt has such an unforgettable green color!

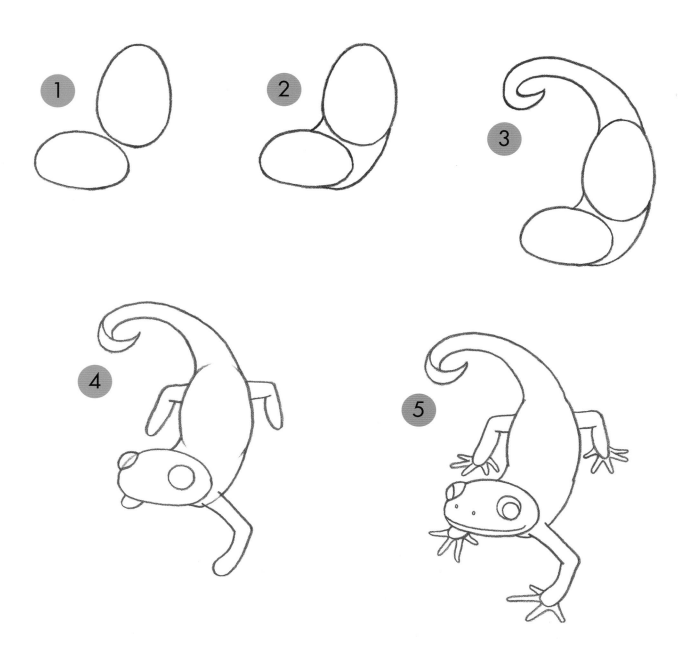

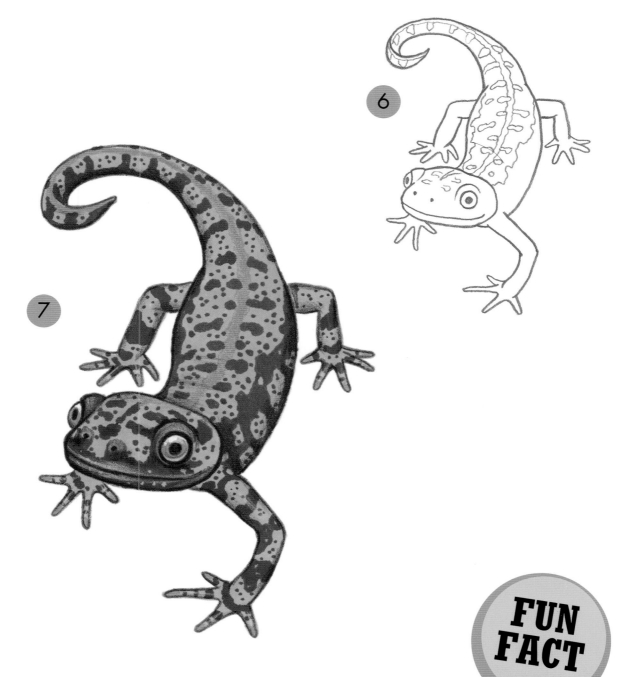

6

7

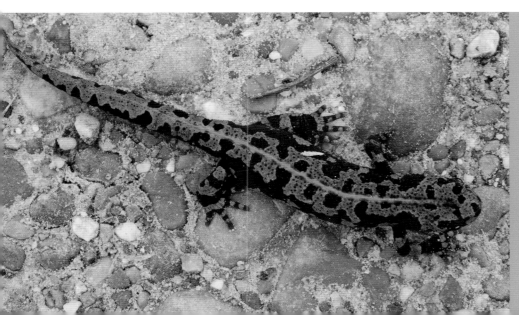

This European newt has
true self-healing powers!
If it loses a limb (such
as an arm or a leg), it
will grow one back in
its place! This talented
species can only
be found in Spain and
in the south of France.

King Cobra

This snake **rears** off the ground and **flattens** its wide hood when threatened—characteristics that make the cobra instantly recognizable.

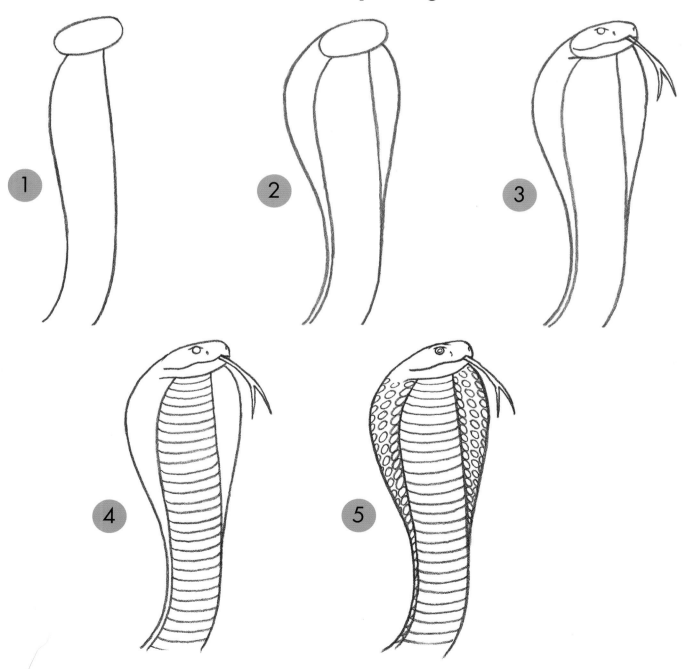

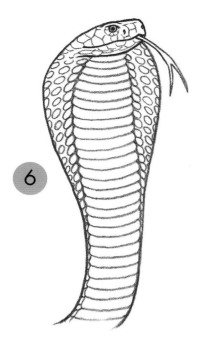

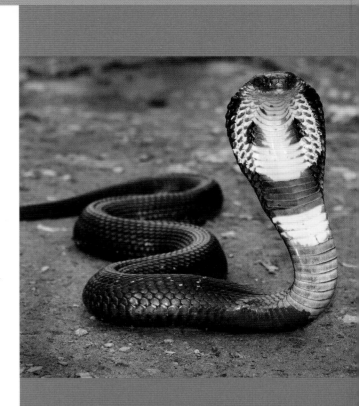

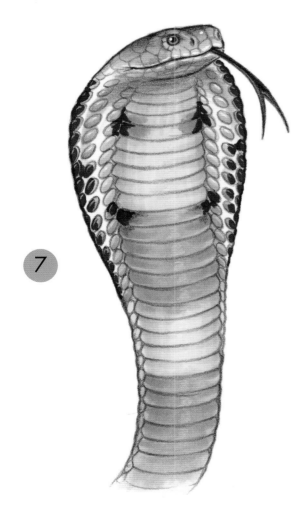

The king cobra is the largest venomous snake. It can grow to more than 18 feet long and can release enough venom in one bite to kill a large elephant—or 10–13 people! But this snake isn't a threat, as it lives deep in the forests and avoids human contact.

Red Salamander

This **poisonous** salamander has no lungs, so it must use its external **gills** to breathe. The older it gets, the darker its spots become.

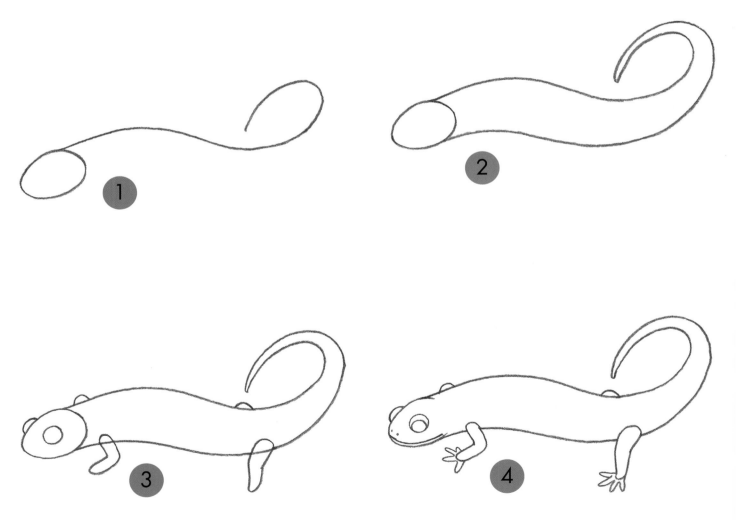

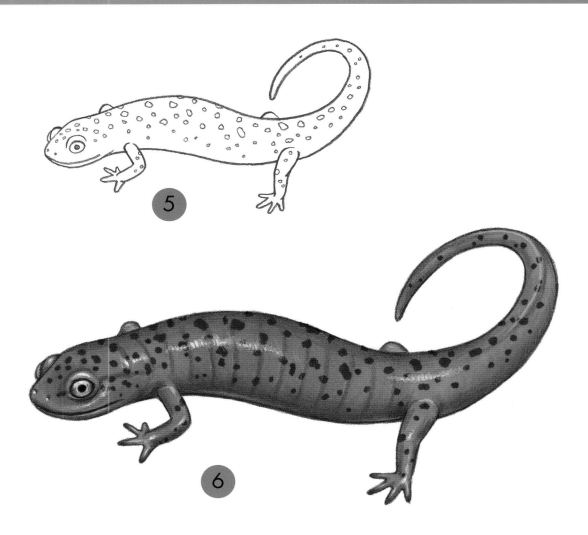

5

6

FUN FACT

All newts are salamanders, but not all salamanders are newts. The word "salamander" refers to an entire group of amphibians that have tails as adults. "Newt" is more specific— it describes salamanders that spend most of their time living on land.

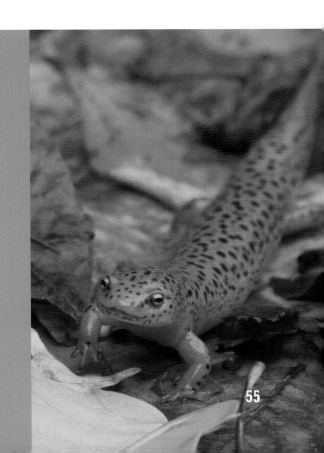

Violin Beetle

Long and **flat**, this member of the **ground** beetle set gets its common name from its head and body outline.

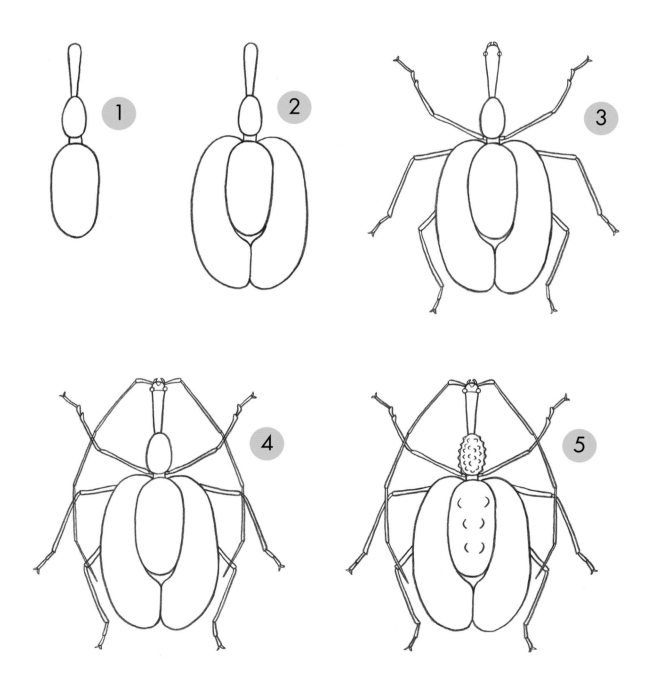

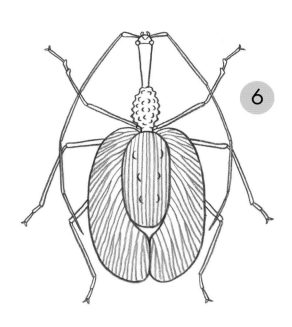

6

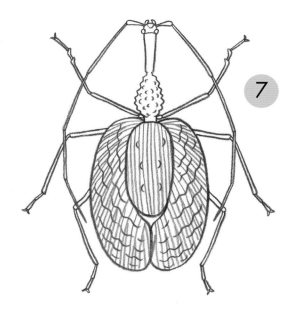

7

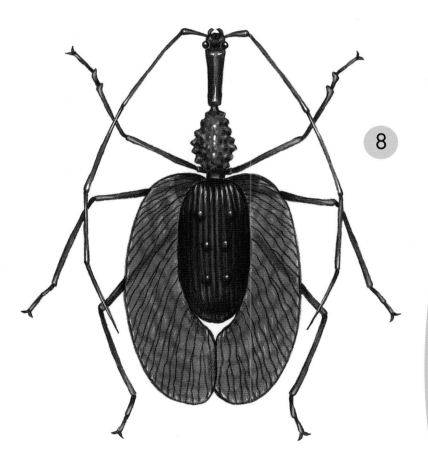

8

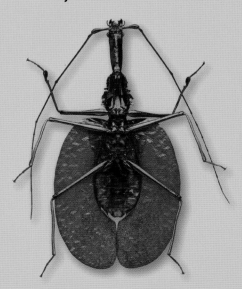

Alligator Snapping Turtle

The **sharp**, pointy shell—or "carapace"—of this snapping turtle is almost as interesting as its powerful **hooked** jaw!

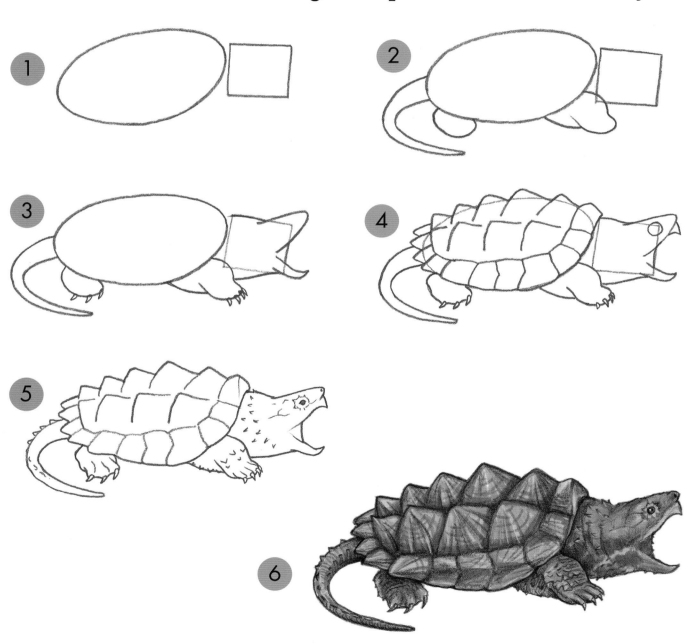

Madagascan Leafnose Vine Snake

When this snake is still, its **unusual** snout camouflages it in the trees. The female has the most **elaborate** snout; it looks like a pine cone!

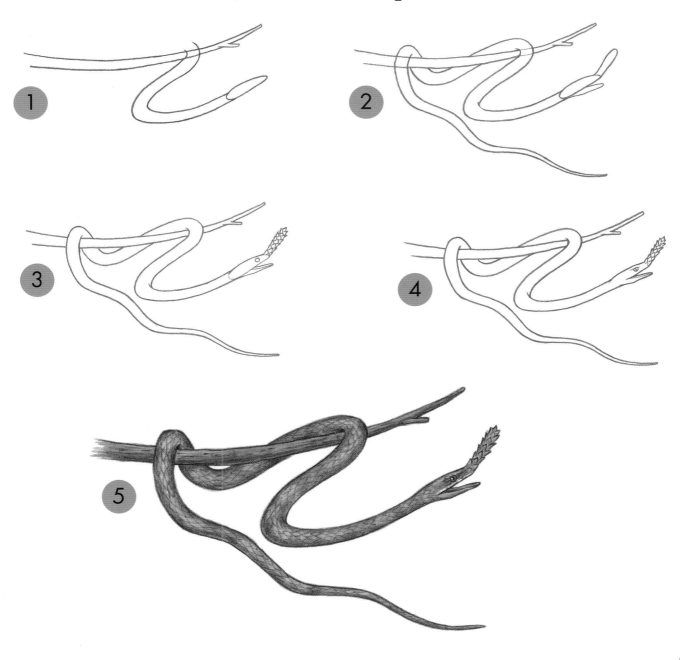

Thorny Devil

Covered in cactus-like **spines** from head to toe, this lizard looks mighty intimidating—until you learn it's only **palm-sized!**

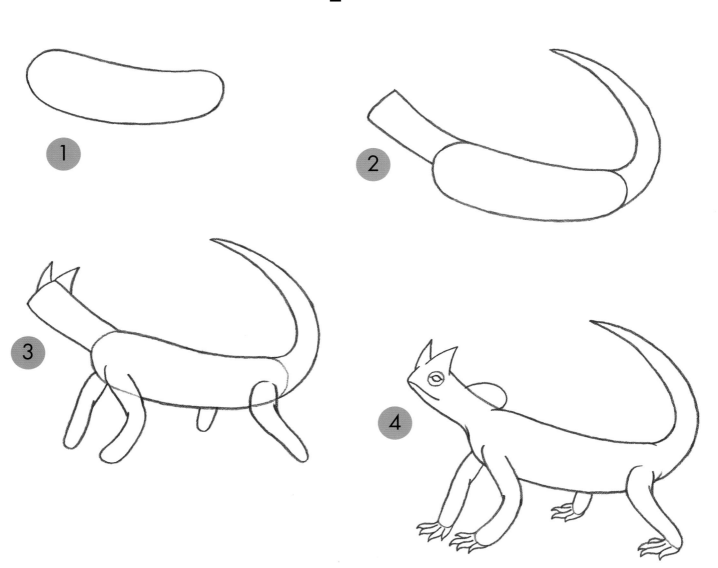

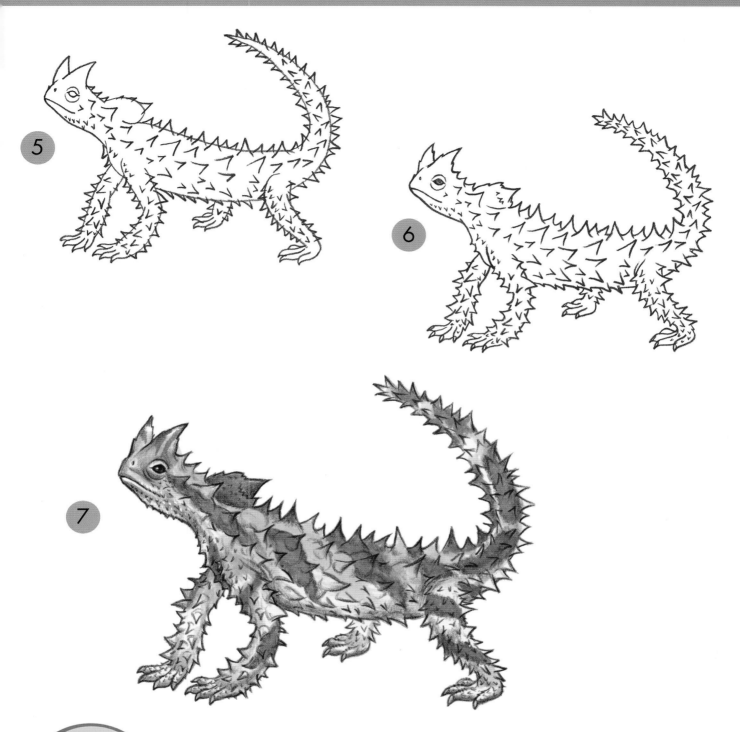

5

6

7

FUN FACT

Despite its fierce appearance, the thorny devil isn't at all threatening. This tiny, slow-moving creature grows to be 8 inches at most! And it's one of the least aggressive reptiles—when approached by a predator, it simply hides or pulls its head between its front legs for protection.

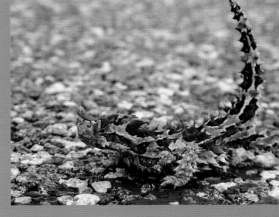

Common Scorpionfly

Narrow, banded **wings**, a beaked head, and a slender body distinguish this bug. The male's abdomen has a scorpion-like tip.

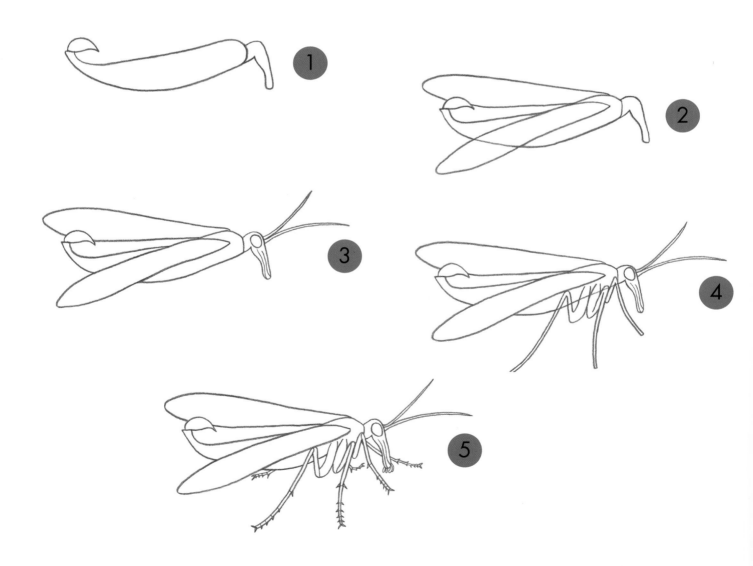

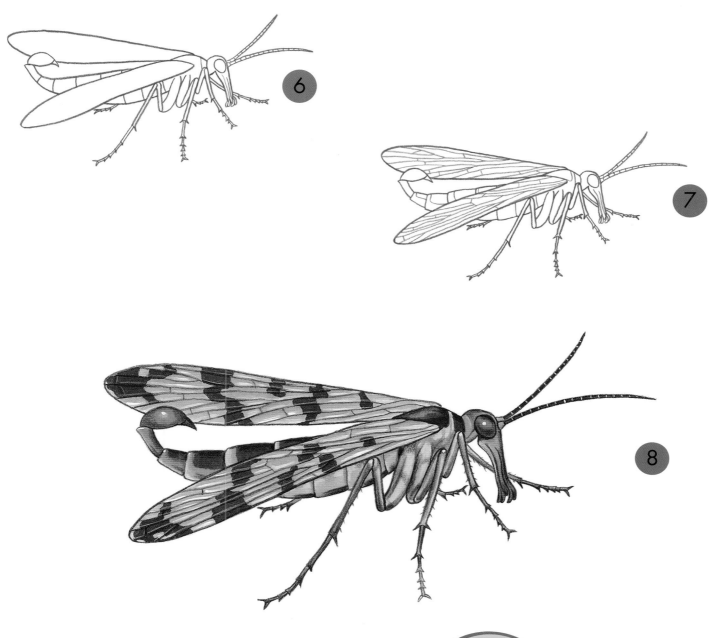

6

7

8

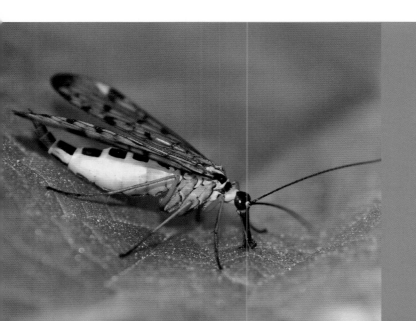

FUN FACT

The adult common scorpionfly rarely flies very far, and instead spends most of its time crawling on vegetation in cool, damp places.

Blue Poison-Dart Frog

Small but **dangerous**, the intense **coloring** of this endangered tree-climber lets predators know that it is extremely poisonous!

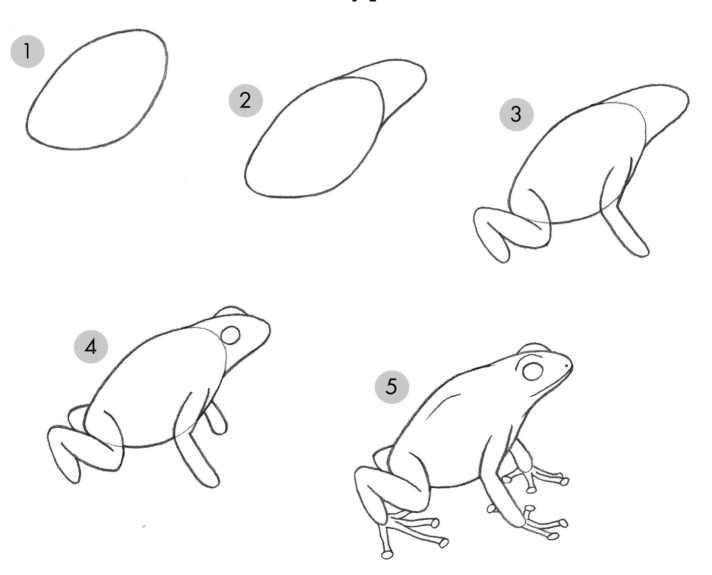

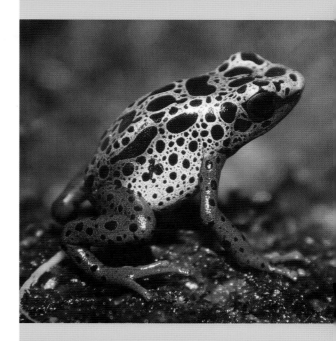

Members of one Colombian rainforest tribe use leaves to capture these frogs, killing them for their poison—which they use to tip their blow-dart arrows. The poison is so toxic that one drop can kill an adult human!

Chactid Scorpion

Pinching claws and a **stinging** tail separate this arachnid from its spider cousins, despite its pedipalps and eight legs.

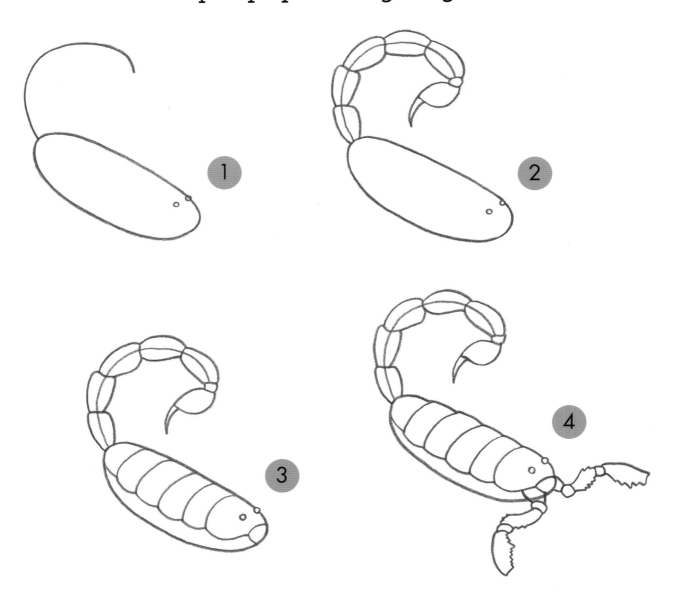

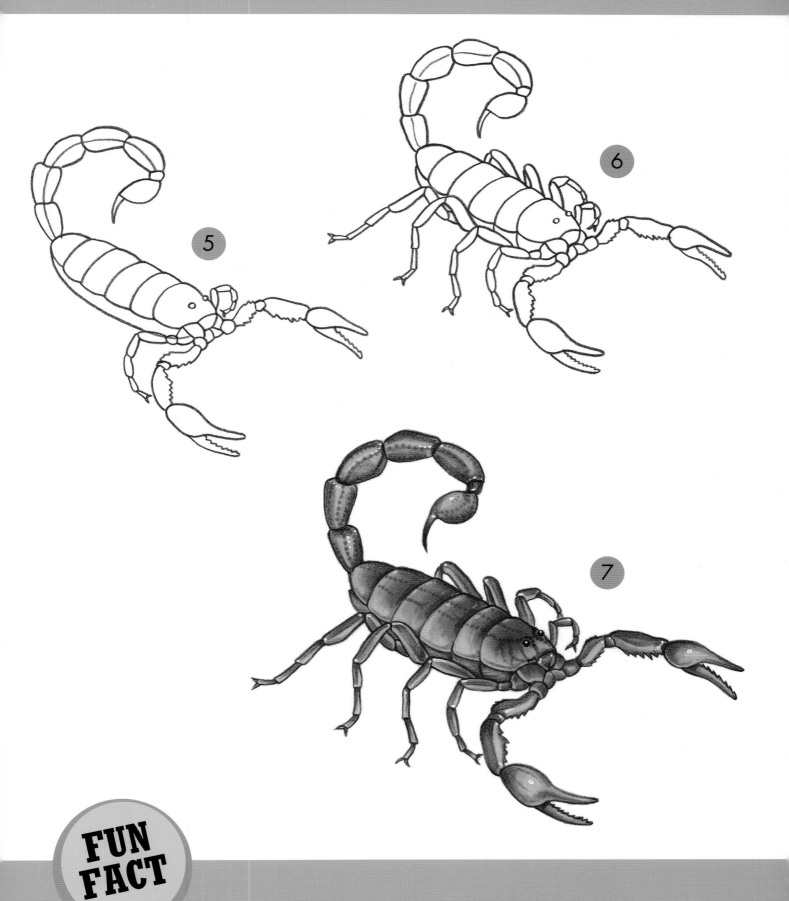

Scorpions are famous for venomous stings—but out of
1,400 species of scorpions, only about two dozen are
truly dangerous to humans. The chactidae family have a
beelike sting, harmless unless an allergic reaction occurs.

Galápagos Tortoise

This ancient-looking tortoise's **massive**, curved shell and heavy, thick **limbs** contrast sharply with its long, slender neck and small head.

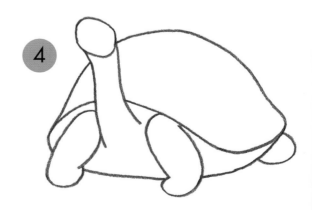

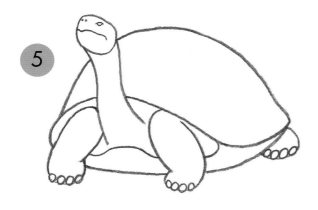

5

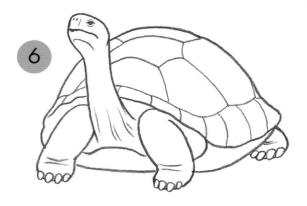

6

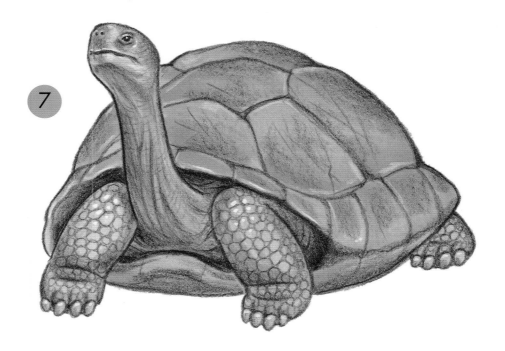

7

Giant tortoises average a lifespan of more than 100 years. The oldest tortoise on record lived to be 152!

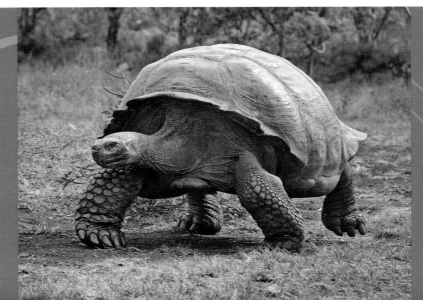

Reticulated Python

"Reticulated" means **net-like**, which is how this **patterned** python got its name. Meet one of the world's longest snakes!

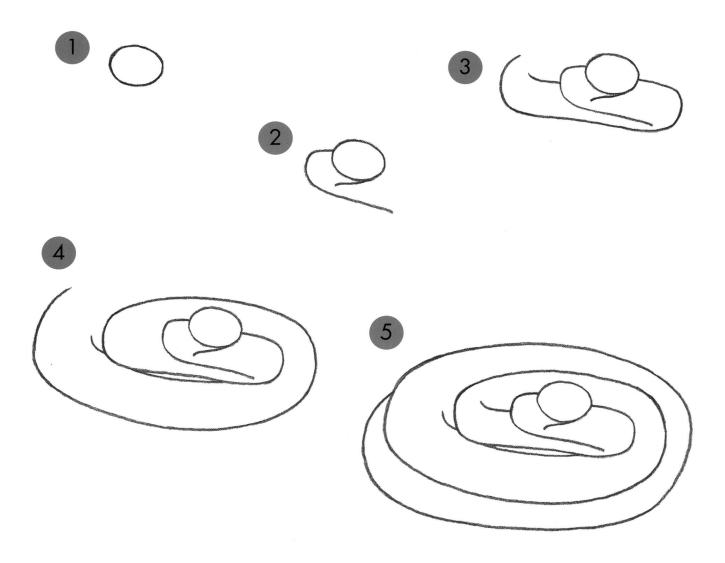

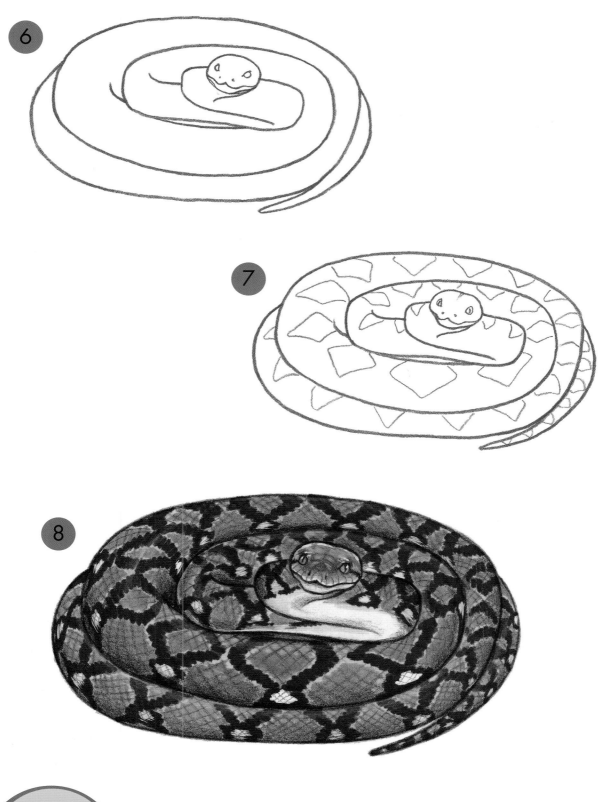

FUN FACT

Pythons move at about 1 mile per hour, but there's no need for them to be quick. They use sight and smell to ambush their food, relying on heat-sensitive pits along their jaws to sense their prey!

Crocodile

A crocodile is a **large**, spiny reptile with **powerful** jaws and super sharp teeth!

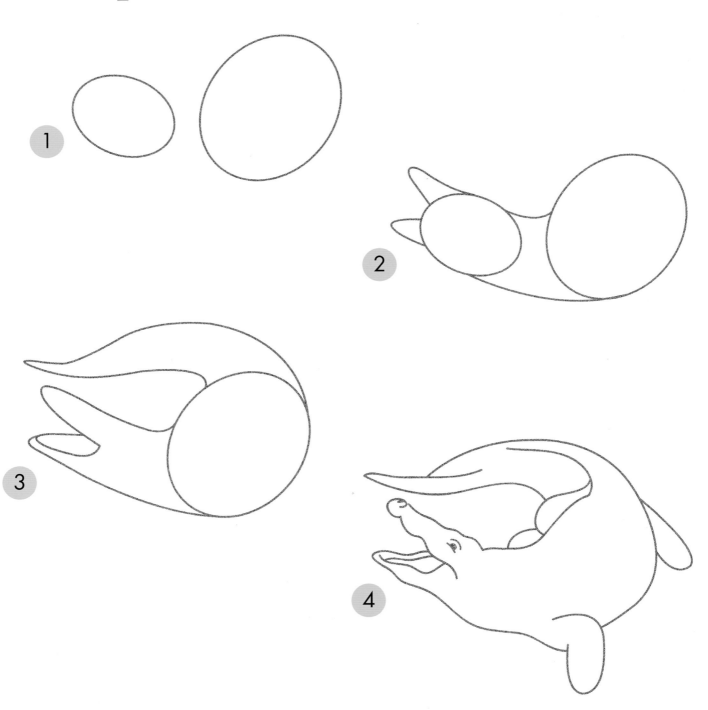

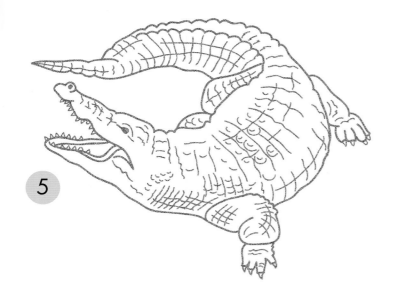

5

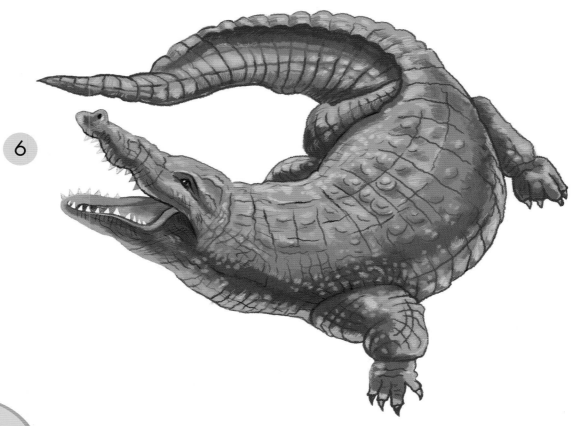

6

FUN FACT

You can tell the difference between crocodiles and alligators by looking at their jaws. Crocodiles have longer, thinner snouts than alligators. Crocodiles also have two long teeth on their lower jaws that stick up when their mouths are closed.

Capybara

The capybara looks like a **furry pig** with a beaver's face and webbed feet.

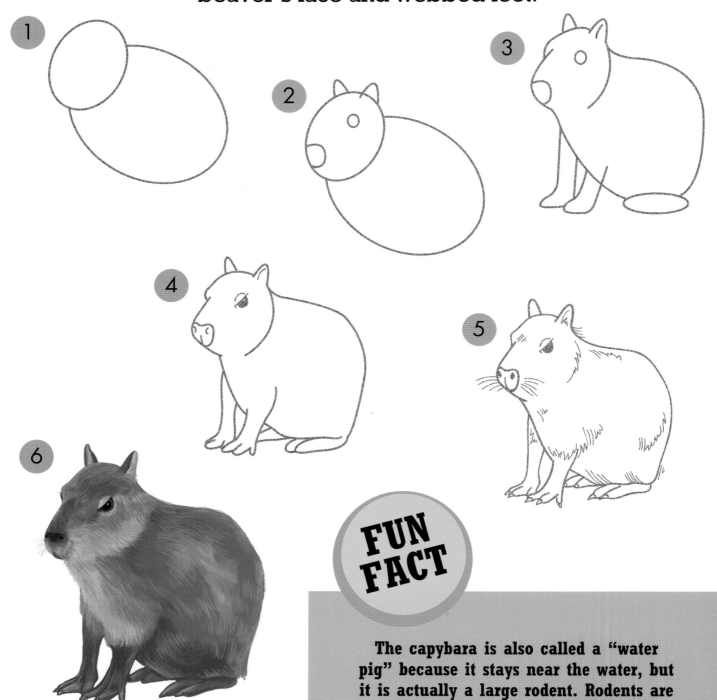

The capybara is also called a "water pig" because it stays near the water, but it is actually a large rodent. Rodents are a group of small mammals that include guinea pigs, mice, and squirrels.

Piranha

This **fearsome** fish was named for its razor-sharp **bite**. "Piranha" combines the Portuguese words for "fish" and "tooth."

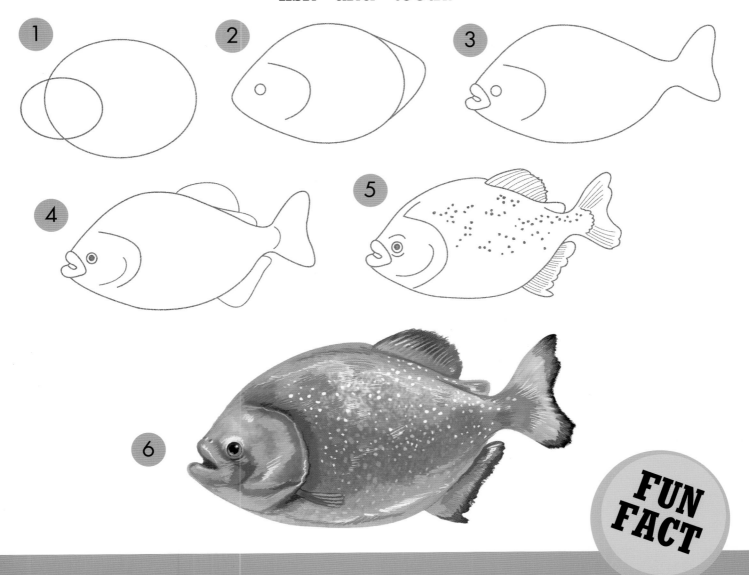

Piranhas have a bad rap. In movies they are shown as blood-thirsty monsters that eat people. However, there is no proof that a piranha has ever killed a person. Piranhas eat both plants and meat, and may feed on larger animals that have been hurt and have fallen into the water.

FUN FACT

Tuatara

This **unique** reptile can only be found in remote New Zealand. Its closest **dinosaur** relatives went extinct over 65 million years ago!

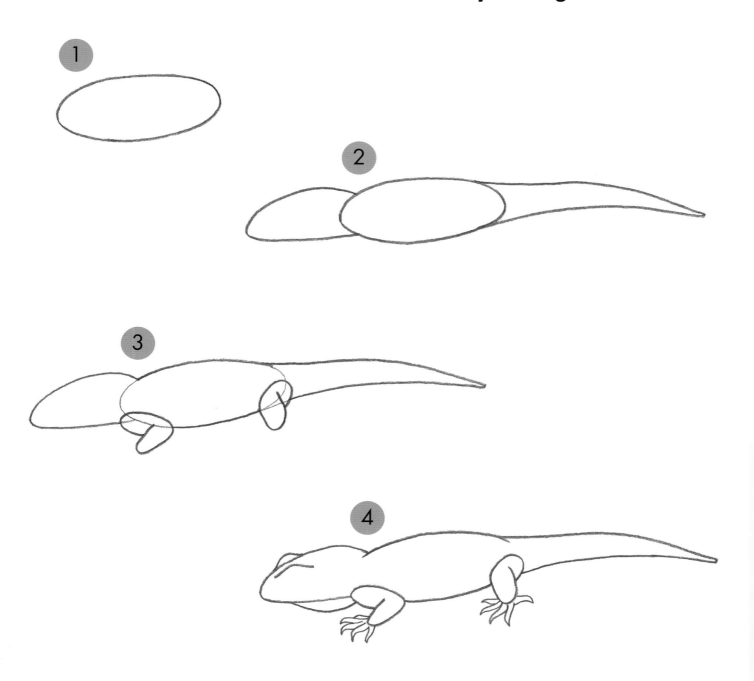

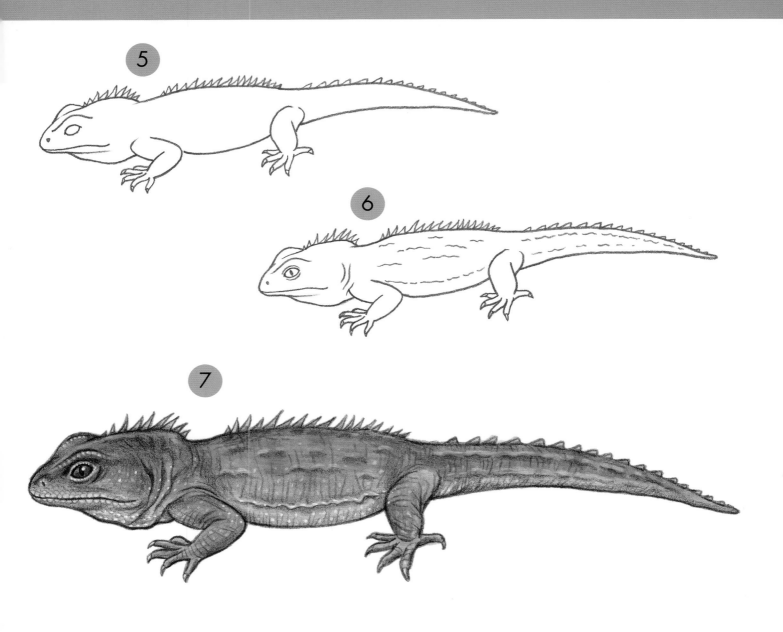

5

6

7

FUN FACT

The tuatara has three "eyes"—two you can
see and a third hidden atop the reptile's
head. The third eye has a retina, lens, and
even nerve endings, but it isn't used to "see"
the visual world. Instead it senses light, and
it may help the tuatara judge the time of day
or the season.

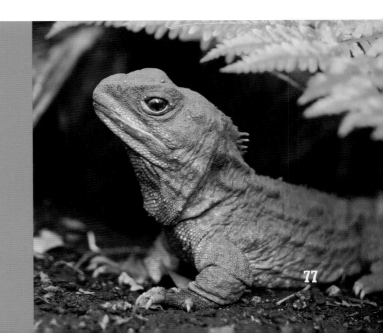

Leopard

Leopards have **dark** spots on their **fur**. These markings help them blend into forests or grasslands.

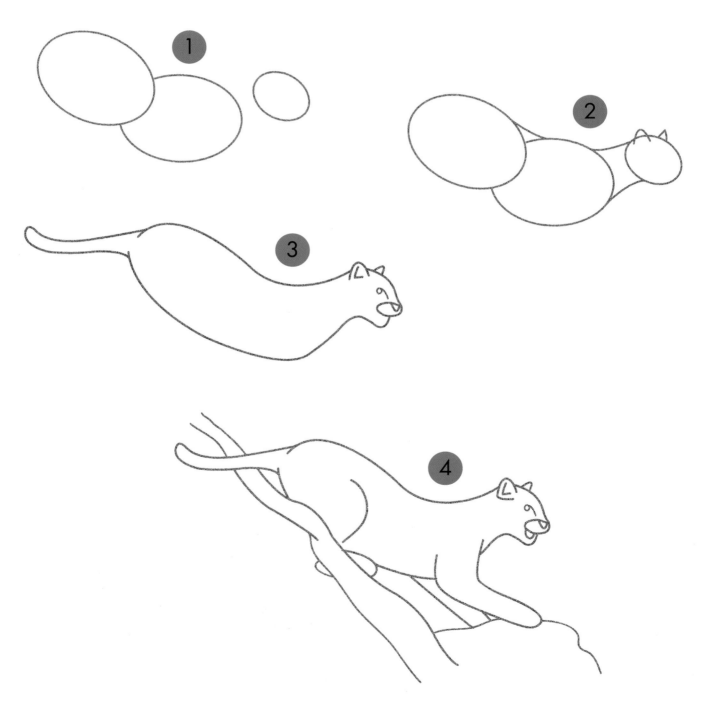

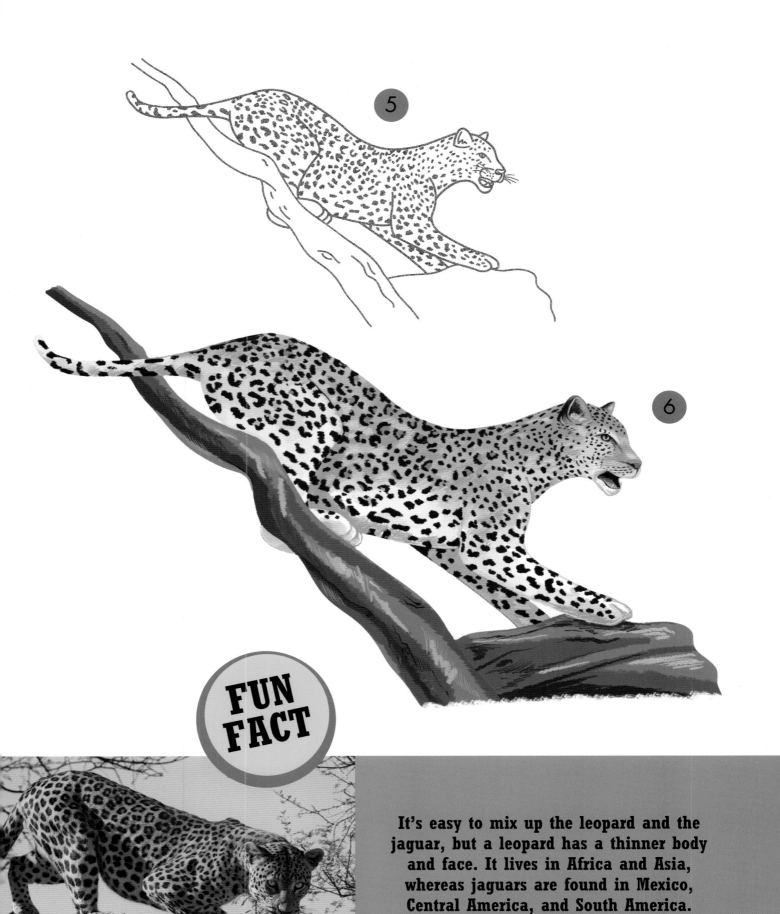

5

6

FUN FACT

It's easy to mix up the leopard and the jaguar, but a leopard has a thinner body and face. It lives in Africa and Asia, whereas jaguars are found in Mexico, Central America, and South America.

Glossary

Endangered (en-deyn-jerd) - In danger of dying off, or becoming extinct.

Extinct (EK-stinct) - No longer living or existing.

Habitat (HAB-i-tat) - Where an animal lives, such as the rainforest or the desert.

Herbivore (hur-buh-vohr) - An animal that eats only plants.

Native (ney-tiv) – Born or from a particular place or country.

Omnivore (om-nuh-vohr) - An animal that eats many different foods, including plants, fruits, and other animals.

Predator (PRE-da-tur) - An animal that kills and eats other animals.

Prowl (proul) – To hunt for something, such as prey or food. When an animal is on the hunt for another animal.

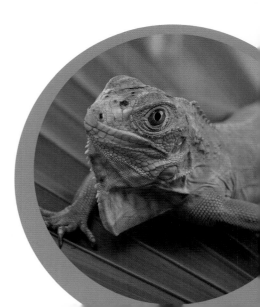